The Make Believe World of
MAXFIELD PARRISH
and SUE LEWIN

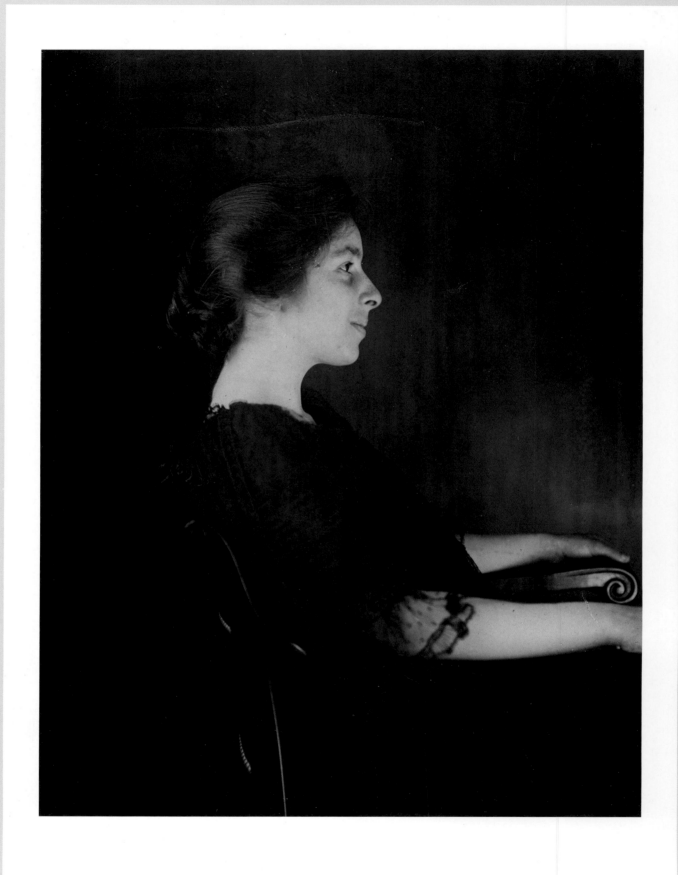

The Make Believe World of
MAXFIELD PARRISH
and SUE LEWIN

ALMA GILBERT

TEN SPEED PRESS
Berkeley, California

To Jack Wallace, therapist, friend.
You made me believe once more.
Thank you.

Ten Speed Press
Post Office Box 7123
Berkeley, California 94707
www.tenspeed.com

Distributed in Canada by Ten Speed Press Canada, in New Zealand by Southern Publishers Group, in South Africa by Real Books, and in the United Kingdom and Europe by Airlift Books.

Design by Bonnie Smetts Design

Library of Congress Cataloging-in-Publication Data:
 Gilbert, Alma.
 The make believe world of Maxfield Parrish and Sue Lewin / Alma Gilbert.
 p. cm.
 Originally published: San Francisco: Pomegranate Artbooks, ©1990.
 ISBN 0-89815-936-9
 1. Parrish, Maxfield, 1870–1966—Relations with women.
 2. Lewin, Sue, 1889–1978. 3. Artists' models—United States—Biography.
 I. Title
 [ND237.P25213G55 1997]
 759.13—dc21
 [B] 97–14112
 CIP

Originally published by Pomegranate Artbooks
First Ten Speed Press printing, 1997
Printed in China
3 4 5 6 7 8 9 10—08 07 06 05 04

Contents

Foreword

In 1978, to coincide with the recent opening of The Maxfield Parrish Museum, I suggested to Les Allen Ferry, a devoted Parrish collector, that a compilation of some of the photographs that Parrish had done of Sue Lewin might be assembled in a small book, showing the photographic images and the paintings that emerged from them. I had *The Make Believe World of Sue Lewin* published to raise funds for the non-profit museum. This book is an expansion of that initial modest effort, with a more comprehensive record of Sue and Parrish's relationship.

Then and now, I am grateful to Mrs. Betty Skillen, Sue's niece and executrix of her estate, who so graciously allowed me to use the glass slides that Parrish gave Sue of the many photographs he took of her. I'm also grateful for the cooperation of Warren Westgate, Sue's cousin, who fortunately was very interested in photography, geneology and history. Sadly, he passed away in November, 1989, the month I completed this manuscript.

Without Betty and Warren's help, recollections and memories, this book would not have been possible. I always will be indebted to them and to Sue Lewin, whose unstinting love and devotion to Maxfield Parrish inspired this book.

A. M. G.

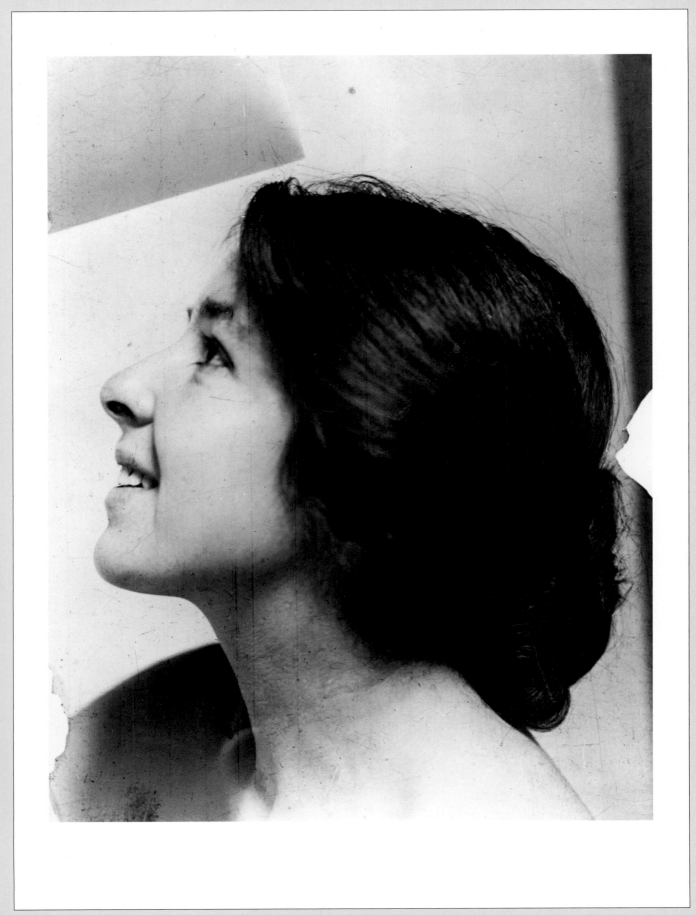

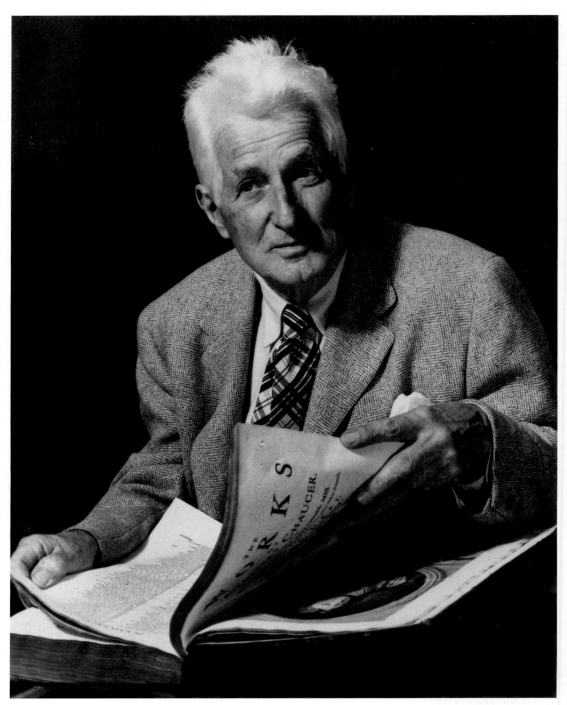

Maxfield Parrish, 1956

Chapter One
MAXFIELD AND LYDIA

Maxfield Parrish (b. 1870) met Lydia Austin (b. 1872), an extremely beautiful and intelligent art teacher, when he attended her classes at the Drexel Institute in 1894. They were married June 1, 1895, in Philadelphia, and they made a strikingly handsome couple. Both had strong temperaments, dogged tenacity and tremendous ambition.

It was evident from the start that in Parrish's life, his art and career would always be its dominant forces, and all else would have to be secondary. Four days after the wedding, Maxfield Parrish sailed without his bride to visit the museums and salons of Europe. He had made earlier plans to spend that summer furthering his career by studying the works of the old masters, and he did not allow his wedding to interfere with the travel arrangements. From Europe he wrote long, chatty newsletters to Lydia, regaling her with the sights and sounds of the continent, the glitter of the salons and the wonder of the Tuileries, Westminster

and Brussels. He seemed to be oblivious to the irony of sending a travelogue of his single honeymoon to his left-behind new wife. That summer set a pattern for the nearly fifty-eight years of marriage that Maxfield and Lydia Parrish would share.

The Parrishes settled in Philadelphia until they moved to Cornish, New Hampshire, in 1898. Maxfield's father, Stephen Parrish (1846–1938), a well-known artist and etcher, had moved from Philadelphia to the Cornish Colony, a prestigious artists' colony begun by the American sculptor, Augustus St. Gaudens. In 1894 Stephen Parrish moved into a beautiful home designed for him by Philadelphia architect Wilson Eyre. He named it "Northcote" and invited Maxfield and Lydia to visit him there. Stephen and Maxfield Parrish shared a very special, loving relationship and a comaraderie unusual in the staid Victorian era in which they had been raised.

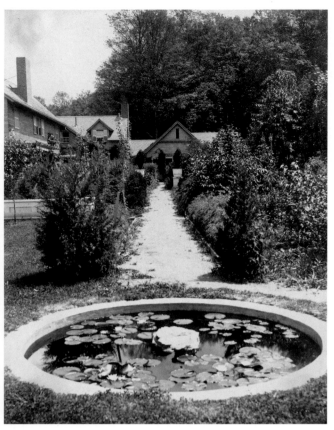

Northcote, c. 1890

The bucolic beauty of the New Hampshire countryside and the stately homes of the great men of the day in the surrounding area prompted young Maxfield to purchase several hillside acres from Charles Williams, a local farmer, with $950.00 advanced to him by his father. Although Maxfield and Lydia enjoyed the city life of Philadelphia and its opportunities to attend concerts and frequent art exhibits, they left it for their new property, which looked across the valley to Stephen Parrish's Northcote. There they began building "The Oaks," the estate where they would live for the rest of their lives.

Soon after the move, Parrish contracted tuberculosis, and the subsequent monetary pinch caused Lydia and Parrish to be on the verge of losing The Oaks. Fortunately, Parrish was commissioned to illustrate Kenneth Graham's *Dream Days* just in time to thwart the impending financial difficulties. But because the property was so important to Parrish, the stress of almost losing it was debilitating. There are allusions in the Parrish family correspondence to "Dad's N.B." (nervous breakdown) early in his career. In the Parrish Family Papers and in the American writer Winston Churchill papers at Dartmouth College Library, there are letters to a New York

sanitorium. Churchill, one of Parrish's closest friends, sent the sanitorium located in the Saranac Lakes region five hundred dollars to reserve space for an anonymous friend who was not going to register under his own name. In fact, at his doctor's recommendation, Parrish spent the winter of 1900–01 recuperating at Saranac Lakes. He continued to paint, and he was given a commission by Century Magazine for the "Great Southwest" series, which allowed him to continue his convalescence in Castle Creek Hot Springs, Arizona, during the winter of 1901–02. Lydia accompanied him.

Building site of The Oaks, c. 1898

Parrish wrote to his cousin Henry Bancroft in 1901 from Arizona, "You get a sense of freedom and vastness here that I never imagined existed. . . Lydia is a regular Annie Oakley, rides the desert horses astride, and is a crack shot with a six shooter. But shooting people is considered bad form here nowadays, so she has to content herself with targets . . ."[1]

After regaining his health, Parrish was eager to go back to his New Hampshire home and resume his painting and the building of the estate. He and Lydia arrived at The Oaks in April, 1902, in time for spring planting. Their return was marked with renewed vigor. Lydia busied herself

Night in the Desert, Illustration for "The Great Southwest, Part II: The Desert," *Century Magazine*, 1902

with her gardens, aided by cuttings and seedlings that had been started in the Stephen Parrish greenhouse. She also resumed her own painting in a small cabin within the property away from her husband's highly critical eye.

This was one of the few happy periods of Lydia Parrish's married life. With a young and successful husband at her side, an easing of financial stress, and no children as of yet to make demands on her, life was comfortable, and Lydia was able to devote more time to her own pursuits.

Parrish's friend Winston Churchill (1871–1947) and his wife, Mabel (1873–1945), moved to Cornish about the same time as the Parrishes. They settled in their sumptuous house, "Harlakenden," designed by the famed architect and Cornish resident, Charles Platt. The Churchills and the Parrishes were the same relative ages and ideally suited contemporaries. Their sense of humor, tremendous talent, attractiveness and upper-crust, cosmopolitan vitality made them close, congenial neighbors and lifelong friends. Churchill had married the former Mabel Harlakenden in 1895, the same year the Parrishes had wed. Mabel was an attractive heiress whose independence and spirit matched those same qualities exhibited by Lydia Parrish. Also, like Lydia, she was an ardent suffragist and enjoyed traveling and painting.

In 1903, Parrish accepted a Century Magazine commission to illustrate the upcoming book by Edith Wharton, *Italian Villas and Their Gardens*, which the magazine was going to serialize. For this project, of course, Parrish needed to visit Italy, and, buoyed by Mabel's encouragement, Lydia accompanied her husband on her first European trip from March to June. The trip sparked a love of travel that would remain with Lydia throughout her life, as well as a special closeness between husband and wife. Later, Lydia was to visit Europe many more times, but this was the only trip she would make with her husband.

In December of 1904, the first of the four Parrish childen, John Dillwyn, was born. As was the custom of the day, Dillwyn was born at home, and Lydia had a nurse come in and help her during her confinement. Maxfield, Jr. was born in August of 1906, followed by Stephen in 1909 and Jean, in 1911.

After the birth of their last two children, the Parrishes hired tutors to teach Dillwyn and Max, Jr. music and several academic subjects. Parrish was known to pop into the nursery, make funny faces at the children and entertain them with quick little drawings to illustrate a story or a point in their lesson.

Marguerite Quimby was a general tutor to

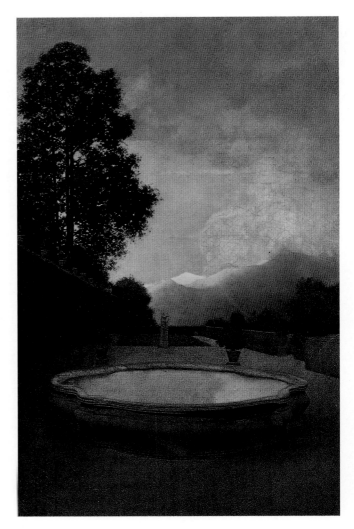

Villa Cicogna, Bisuschio from *Italian Villas and Their Gardens* by Edith Wharton (The Century Company, 1904)

Lydia, Max and Dillwyn Parrish, 1907

the Parrish children at the time. She taught them year round, including summers. During an interview in 1979 for The Parrish Oral History, she related the following:

> Mr. Parrish had to come and get me every day [to tutor]. He'd pick me up and took [*sic*] me up there. And we had marvelous visits on those trips. I remember one day he came and said, "This is a Monday. I'm supposed to like blue very much, but I don't like blue Mondays." And everyday he would tease me by saying, "What do you say we go look at oak trees, look at interesting things. Let's not go on the job and work, either of us." And I was very prim and proper and I thought, "This is dangerous! This is a wild man!" But he had a great sense of humor.[2]

By 1909, Lydia had begun absenting herself during the winters. The Parrishes had an apartment in New York, and she enjoyed plays, theatre, the opera and the ballet. It also gave her time to write and seek out her talents away from the tremendous popularity of her husband's work.

Lydia and Jean Parrish, 1912

The Oaks

Chapter Two
THE OAKS

The grand estate "The Oaks" was largely Maxfield Parrish's own vision, with much of it based on his own drawings and work as a carpenter. At first, he did most of the building himself. He had not drawn detailed plans, but his innate, highly developed sense of architecture aided him in designing the house. By the end of winter in 1898, a modest four-room cottage sat nestled between giant oaks, boulders and hip-high snow.

As Parrish gained more and more commissions and book illustrations, he began to expand the house from its original kitchen, living room and two bedrooms. Parrish hired a general handyman, George Ruggles (whose land was adjacent to the Parrishes'), to help with the construction.

Lucy Bishop, Ruggles' daughter, remembered her father's stories of The Oaks taking shape when she said, "[Dad commented that] 'the house started as a rectangle and then it grew like Topsy: north, south, east, west and up.' Mr. Parrish would just pace a few steps, look the territory over, and then drive a stake in the ground. 'Bring that west wall up to here, George,' he'd say, and Dad would do it. There were never any architectural plans for The Oaks; they were all in his head."[3]

The Oaks, built following the natural contours of the hillside, had fifteen rooms and five bathrooms when Parrish and George Ruggles finished their building labors. The last addition, the music room, was added in 1906. Lydia was an accomplished pianist, and she frequently invited other musicians to perform there. It was twenty feet wide and forty feet long with graceful arched windows designed to slide open and disappear into the walls to afford the viewer an uninterrupted view of the spectacular vista extending like a

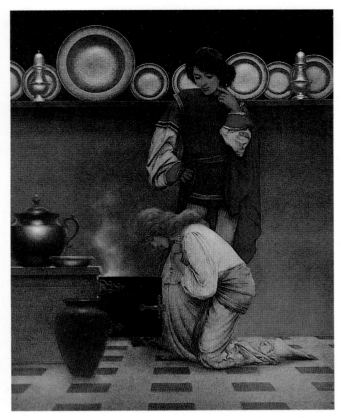

Violetta and Knave Examining the Tarts from *The Knave of Hearts*

blue and green canopy below. The beamed ceiling was almost fourteen feet high. The parquet floors were oak, and the oak paneled walls were stained a dark grey-black with tones of blue (Parrish's favorite color) for highlights.

A nine-feet-high baronial fireplace dominated the cavernous room. A person could stand on tiptoe and not reach the top of the mantle. One end of the room was occupied by a stage, which could be walled off with three matching oak panels. The panels, placed in specially-designed grooves, looked just like a wall and effectively hid the stage behind them. Bookcases lined the walls and a massive grand piano sat in the corner of the room.

The dining room was also completely paneled, with cozy seats built next to the fireplace. Parrish's collection of pewter pieces, used frequently as props in a number of his paintings, lined the built-in shelves. Brass latches and ornate hinges designed and crafted by Parrish in his machine shop were used on doors and cupboards. (They also appeared in a number of his illustrations, most notably those for Louise Saunders' *The Knave of Hearts*.)

Next to the dining room, a beautiful open-air porch presented an incomparable view of Mount Ascutney, the large extinct volcano. In the back of

the porch two plaster lions sat in regal splendor atop two columns, and an inscription carved by Parrish in the back wall read, "ANNO DOMINI: MDCCCXCVIII." A reflecting pool directly in front of the porch mirrored the changing cloud formations and the surrounding flower gardens. (Parrish used the setting of this porch in his painting for the frontispiece of Arthur Cosslett's Smith's *Turquoise Cup* with himself as the figure of the archbishop.)

The Parrish gardens exhibited Lydia Parrish's fantastic green thumb. Hollyhocks, lilacs, grape arbors, cascading spirea and fragrant apple blossoms converted the property into a veritable fairyland. A distinctive stone archway within the gardens completed the perfect, picturesque setting. (Present-day erosion has exposed a construction secret of the arch. The masons evidently consumed a quantity of wine during their lunch hours. Their buried bottles in the cement of the stone gateway are now an amusing testimony to the rigors of their labor.)

The expansive house nevertheless proved to be still too small for Parrish. When Dillwyn was born, Parrish found the distractions of life in the main house intruding into his painting time. So he hired George Ruggles to build a fifteen-room studio across the lawn, about forty feet away

Reflecting Pool, The Oaks, 1920

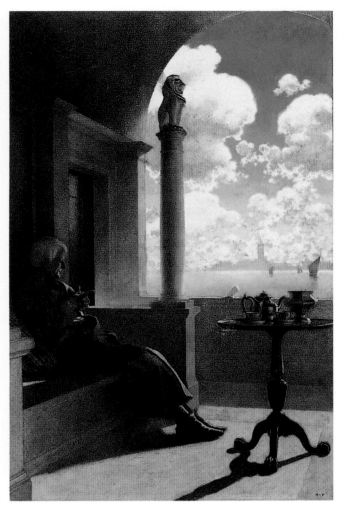

Cardinal Archbishop, 1901, from *Turquoise Cup* by A. Gosslett

from the main house, where he could store his beloved machinery and paint undisturbed by wife, children and servants.

The elaborate studio contained three bedrooms, a kitchen, two painting rooms, two bathrooms (although a double-seated outhouse still stands outside the studio), a darkroom, storage rooms for props and a sophisticated machine shop that probably was the envy of every machinist within miles around.

Since Parrish often painted from photographs, his darkroom was very well equipped. He designed it with black painted wooden panels to fit in the window to exclude all light when necessary. The two-door entryway was cleverly engineered so that the second door closed automatically by a counterweight contained in a brass pipe. A sink for solutions and chemicals stood next to a motorized agitator for mixing developing fluids.

Across from the darkroom in one of his painting rooms, Parrish equipped a closet with a counterweighted projector for his four-by-five-inch glass plate negatives. The other painting room was designed for creating oversized murals. It had a trap door to facilitate moving the murals.

For the rest of his life, Parrish drew immense joy from the beauty of his surroundings. He

Garden Gate with Hitching Posts, The Oaks

wrote to his friend and patron Irenee Du Pont describing The Oaks:

As you descend some steps from the upper level to the house terrace, through them and beyond them, you have a confused sensation that there is something grand about to happen. There is a blue distance, infinite distance, seen through this hole and that, a sense of great space and glorious things in store for you, if only you go a little further to grasp it all. It takes your breath away a little, as there seems to be just blue forms ahead and no floor. Then you come upon the lower terrace and over a level stone wall you see it all, hills and woodlands, high pasture, and beyond them, more and bluer hills, from New Hampshire on one side and from Vermont on

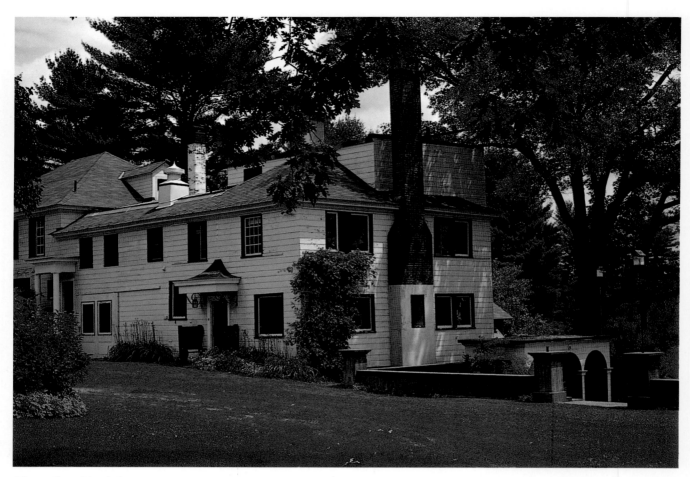

The studio at The Oaks

the other, come tumbling down into the broad valley of The Connecticut with one grand mountain over it all.[4]

Even though the main buildings of The Oaks were completed by 1906, Parrish employed the services of George Ruggles for over thirty-five years, and a very special friendship developed between the two men. Occasionally, Parrish even persuaded Ruggles to model for some of his paintings. As Parrish once commented to a visiting neighbor, "I can always depend on George to come and pose for me for a picture, particularly, if there's food involved." Ruggles posed for a number of paintings including the Jello ads *Polly Put the Kettle On* and *Tea Tray* (see pages 42 and 43). The friendship of Parrish and Ruggles was genuine and sincere. When Ruggles died in 1931, Parrish sent his wife the following note:

Garden Steps, The Oaks, 1915

September 7, 1931

Dear Mrs. Ruggles:

This is just a word to extend to you and yours our deep sympathy in your great sorrow. I feel almost that people should extend sympathy to me, for Mr. Ruggles was so much a part of our existence here for over thirty years, so much bound up in the growth of this place, that I cannot but feel that his passing is nearly as great a loss to me as to you. His enjoyment of life was so unusual, with his never-failing spirit of eternal youth, that I cannot realize he is gone. Everything here is so intimately associated with him, and will make me miss him for many years to come.

Maxfield Parrish[5]

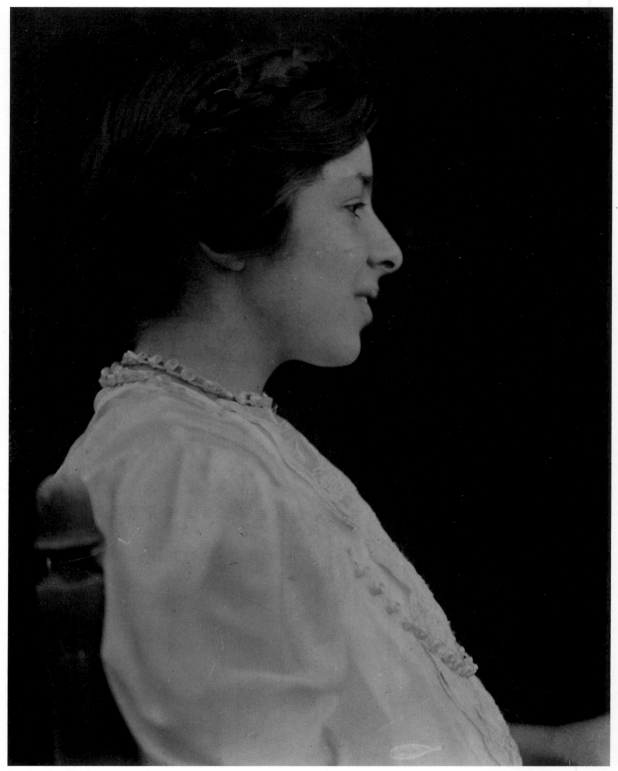

Sue Lewin, 1911

Chapter Three
ENTER SUE LEWIN

The advent of the artists' colony springing up in Cornish with such luminaries as sculptor Augustus St. Gaudens, artists Stephen and Maxfield Parrish, George de Forest Brush, Thomas Dewing, muralist Henry Oliver Walker and the architect Charles Platt brought the little rural communities of Plainfield and Cornish many job opportunities. The industrial revolution had come and gone, and mill towns like nearby Claremont and Windsor no longer provided the needed boost to the economy they once had. Close-knit families, joined into tight bonds through generations of intermarriage, looked at the newly arriving "city folks" with a hostility tempered by the economic realities that jobs in construction, farming and maintenance of their properties were very needed.

The money, the "airs" and the new emphasis on culture kept the two groups, "city folks" and townspeople, at diplomatic arm's length, each needing the services or the monetary outlay that the other could provide. Besides the newcomers, the townspeople also had to contend with a plethora of "summer folks," who came to visit and socialize with the artists.

About a year before the building of The Oaks was completed, and shortly after the birth of Dillwyn, a sixteen-year-old girl named Sue Lewin joined the staff to help Lydia Parrish with the care of her infant son. Sue had been working at Northcote for Stephen Parrish since she was fourteen, and at his suggestion, she readily accepted the new position at The Oaks.

Susan Lewin was born to Elmer and Nellie (Westgate) Lewin on November 22, 1889, in Harland, Vermont. The second daughter of a working class family of five girls and one boy, Sue had to leave her schooling at Quechee High School in Quechee, Vermont, after only two years to become a wage earner. She began her work as a maid for Stephen Parrish on the recommendation of her grandmother, who sold fresh eggs and milk

to both Stephen and Maxfield Parrish. At fourteen, she could well have been compared to the protagonist of an Austen or Bronte novel.

It was at Northcote that Sue first met Maxfield Parrish. She could not possibly have been unaware of the devastating good looks of the charming and witty artist. Parrish had a leonine head with a luxurious crop of hair that at 33 was already beginning to grey. Sue must have noted his deep-set, piercing blue eyes, deeper than any Parrish painted sky; his laugh lines and his strong, determined stubborn chin with its trademark cleft. These attributes were known to make even a very cosmopolitan lady's heart flutter. What, then, could they do to an impressionable fourteen year old?

The first summer that Sue worked at The Oaks caring for Dillwyn, she received a taste of the world she was entering. A host of artists, writers and performers visited the Parrishes. Writer Louis Evan Shipman featured a production of his work *A Masque of Ours* written in celebration of the twentieth anniversary of the founding of the Cornish Colony. All the residents of the colony participated in their roles of gods and goddesses, and members of the Boston Symphony Orchestra headed by Arthur Whiting played the original music composed for the production.

Parrish played the part of Chiron, the centaur. With chest bared, he wore a costume he designed and constructed by stretching fabric over a set of barrel-hoop ribs that attached to the back of his hips. His legs became the centaur's front legs. The back legs of the centaur were equipped with small wheels and were attached to his feet by small, metal rods, so each time Parrish moved a foot, the corresponding rear leg of the centaur's body moved. The appearance of Parrish in the company of the greats of his day must have been overwhelming to young Sue Lewin.

At the same time, Parrish, who had an eye and appreciation for all that was beautiful, could not help notice the young woman recently hired to help care for Dillwyn. Slender and willowy with cascading masses of thick, chestnut brown hair framing a perfect oval face of large, expressive eyes and classic profile, Sue had an aristocratic carriage, and ironically, an uncanny resemblance to Lydia Parrish. Parrish saw Sue as the perfect model for his paintings.

Lydia, now occupied with child rearing and her own painting and writing, no longer had time to pose for her husband. So Maxfield Parrish turned to Sue Lewin to work as his model. Symbolically, the first painting for which Sue posed was *Land of Make Believe*. This marked her own

entrance through the doors of artistic history into a land far removed from the reality of an unsophisticated youngster from a tiny farm town in Vermont. She had truly stepped through some mythical gates into a land of make-believe.

Sue's days at The Oaks grew increasingly busy. Besides helping with the children, she also was charged with cooking for Parrish, making the costumes for his paintings, posing, and seeing to it that he was not disturbed. Parrish's rigorous schedule must have been eased by the young woman who much admired and respected him. Sue tended to him hand and foot, and her character lent itself precisely to that docile, worshipful role. She was untrained but eager, and she probably was infinitely more compliant to his wishes than Lydia. In any case, Sue certainly earned the dollar a day plus room and board that Lydia paid her.

Parrish was a highly disciplined artist, and would brook no interference with his work. Up and painting at six, he would continue his work until midday when he would stop for lunch. Sue fixed Parrish his noontime meals. She excelled in cooking, and many times Parrish raved to neighbors about Sue's apple pies and the impeccable manner in which she poured tea.

Sue had perfect drawing room poise. Her grandmother Luetta Hadley, from whom Sue learned her graceful, "aristocratic" ways, taught her the tea ritual that subsequently delighted Parrish. When weather permitted, Sue served Parrish his tea in the second story shaded porch of the studio.

After his afternoon tea, Parrish puttered in the garden or worked in his machine shop, where he allowed the child in him to have full reign. Neighborhood children, as well as his own, were treated to trucks, railroad cars and other toys handmade by Parrish in his shop. This must have greatly appealed to Sue, still a youngster in her own right. Here was a famous artist who asked her to pose for him, to craft and design the costumes she posed in, and who could enjoy unfettered playtime in his machine shop after his painting schedule was done for the day.

Sue was joined at The Oaks by two of her sisters: Annie, who came in as a cook, and Emily, who was hired to help Sue and Lydia with the children. This must have come as a source of happiness to Sue, who saw very few people her age. Visitors to The Oaks were there to see either Maxfield or Lydia, and the climb of the steep hill on Freeman's Road leading to The Oaks was enough to discourage even the most ardent suitor, particulary during wintertime and early mud sea-

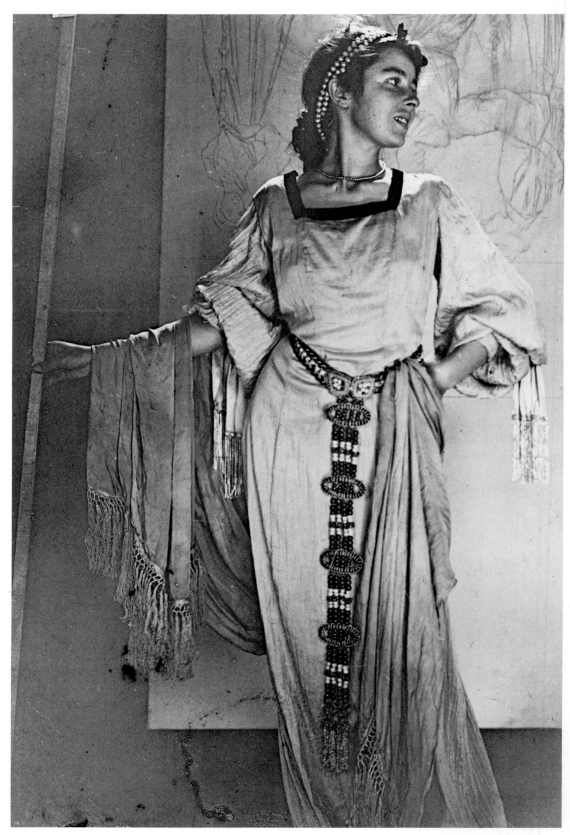

Sue posing for *Land of Make Believe*

Land of Make Believe, 1905. Oil on Canvas, 40 x 33 in.

son. The woods could be practically impassable. Sue had few women friends, probably due to her estrangement from the townspeople in aligning herself with the wealthy "city folk" Parrishes.

Trips to town or to nearby Windsor were infrequent. Sue used to beg Horace Wilson, the mailman, for a rides to town so she could buy herself clothes or trinkets. But when Parrish became the first man in town to buy a motor car, Sue rode to the village with him. She sat proudly by him in the open-air two-seater. She must have felt regal as his companion in the car. According to Sue's cousin Warren Westgate, townspeople would be so impressed to see "one of them" sitting next to Mr. Parrish, that they would bob a curtsy to her, much as if she had been a young queen in the king's carriage. But although they admired Parrish, many of the townspeople snubbed Sue for what they characterized as putting on the airs of her "betters."

This estrangement probably made Sue de-
pend more and more on the attention and companionship of Maxfield Parrish. Three young men who did come courting, Kimball Daniels, Earl Colby and Palmer Reed, took notice of Sue's preoccupation with the artist and began making their treks up the hill less frequently. Kimball Daniels, however, continued his visits as he began courting Sue's sister, Annie. They were married in August of 1911. The handsome, gentle Kimball worked at The Oaks tending the sheep and cows and bringing in the crops. He posed for Parrish as the dramatic figure in *Harvest*, holding a scythe in his hand. Tragically, he was found dead from a broken neck on the Parrish property in April 1913.

Life in the big house continued to be bustling but peaceful, particularly during the summers. Lydia would invite neighbor children up to make ice cream or would organize them to plant gardens and grow their own vegetables. Sometimes the children modeled for Parrish and were paid a quarter a piece for their photo sessions.

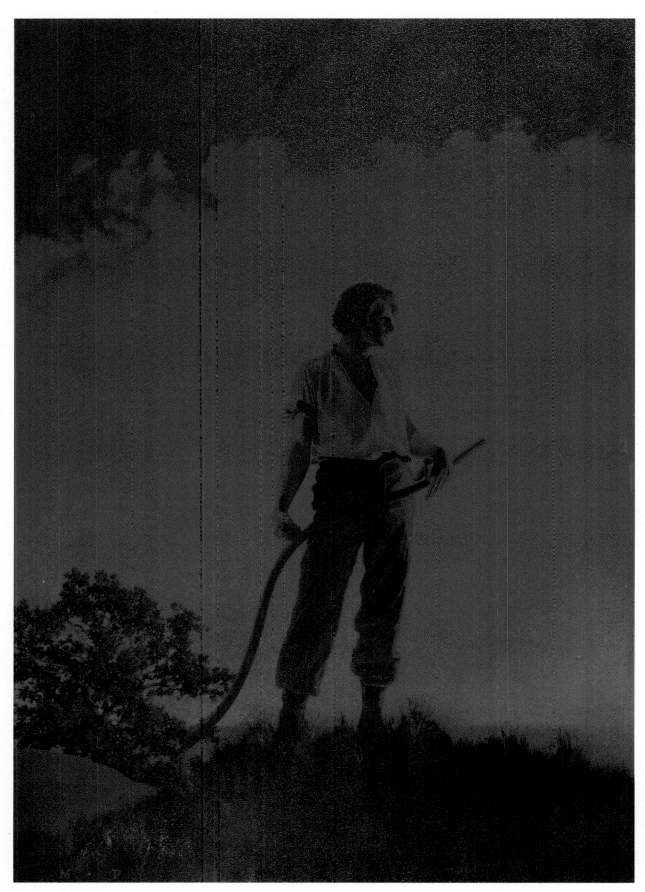

Harvest, 1905. Oil on paper, 28 x 18

Sue Lewin, 1913

Chapter Four
THE PAINTER AND THE MODEL

Maxfield Parrish never actually painted his paintings while Sue, or any other model, posed. His laborious, time-consuming technique of using oil glazes made it impossible to paint from a "live" model. Instead, he made extensive use of photography. He held long shooting sessions in his studio and contact printed his negatives onto glass plates. With these plates he was able to project an image either directly onto the painting surface or onto paper, where he would sketch in the form or cut a stencil. In paintings that included figures, Parrish always finished the underlying landscape first, including the area where the figures would be placed. He then applied the sketch of the figure to the finished landscape, using a stencil or transfer paper, and proceeded to paint the figure over the landscape.

Parrish used varnish between each layer of glaze. The varnish took up to two weeks to dry, so Parrish often worked on several paintings simultaneously.

Sue Lewin's work as a model for Maxfield Parrish became more and more demanding. In 1909 she posed for several of the figures of *The Pied Piper*, a mural commissioned by the Palace Hotel in San Francisco. Parrish then asked her to pose as the figure of Griselda, the faithful, patient young woman selected by a king from the peasantry to become his consort. (One wonders if Parrish was aware of the parallels between Sue's and Griselda's lives.)

In 1910 *Collier's* Magazine commissioned two important covers for which Sue posed: *The Idiot*, which shows Parrish's face in caricature and Sue wearing a polka-dotted outfit, and *The Lantern Bearers*, which presents Sue as six different Pierrots carrying brightly lit lanterns.

Sue's career as a model and her relationship with Maxfield reached a turning point in 1911.

Sue Lewin posing for *Pied Piper*

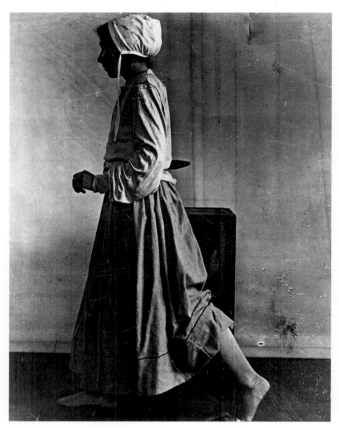

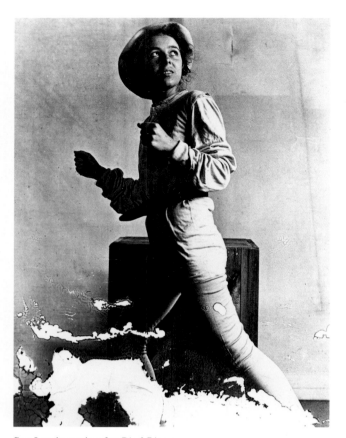

Sue Lewin posing for *Pied Piper*

Sue Lewin posing for *Pied Piper*

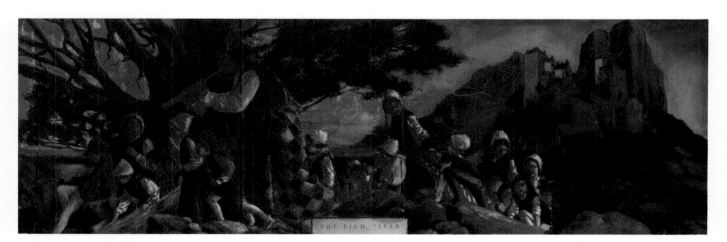

Study for the *Pied Piper*, 1909. Painted photograph, 11 x 36 in. Parrish sent this study to the Palace Hotel to present his color schemes for the mural.

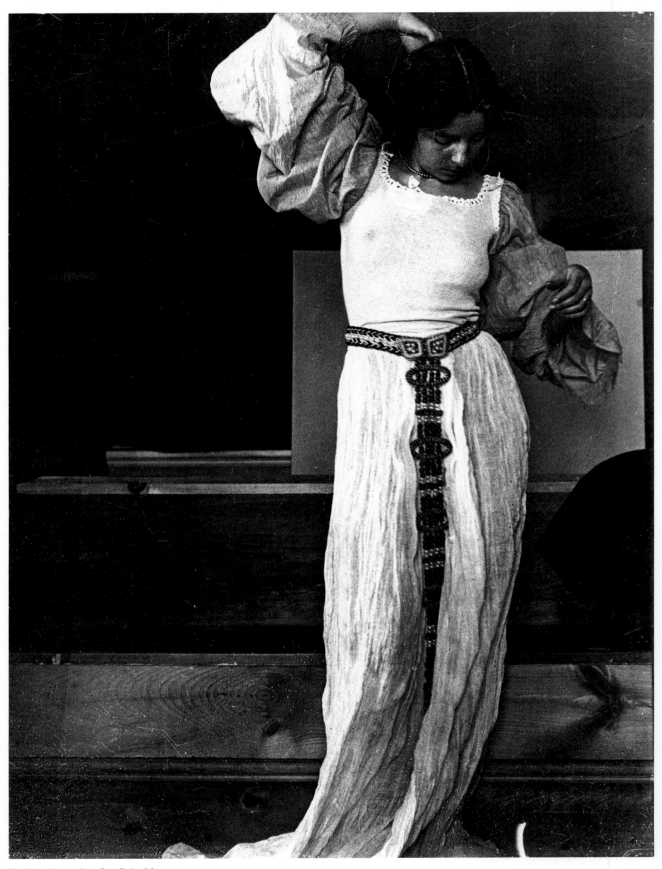

Sue Lewin posing for *Griselda*

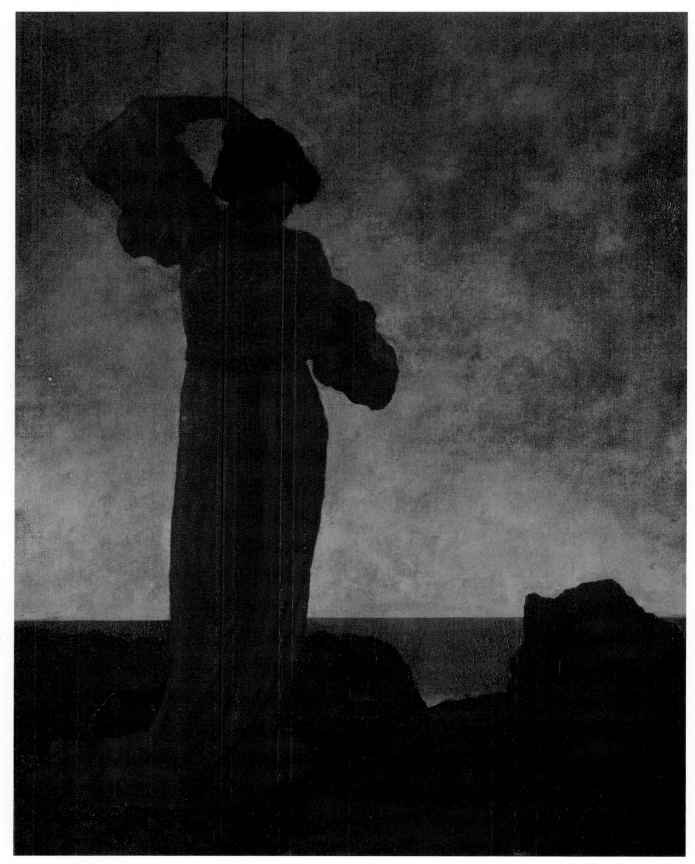

Griselda, 1909. Oil on canvas laid down on masonite, 38 x 31 in.

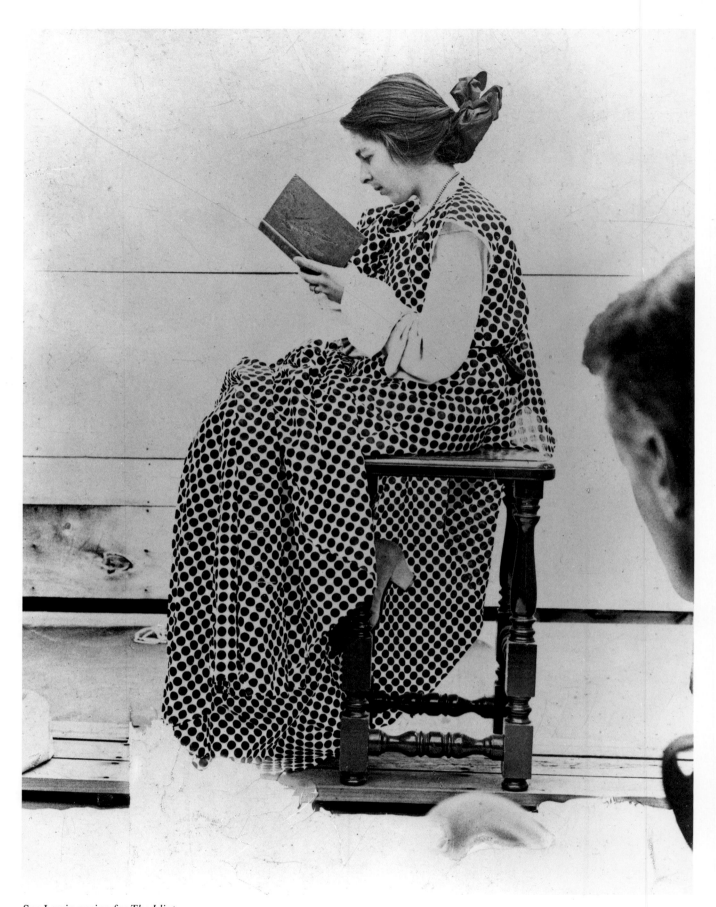

Sue Lewin posing for *The Idiot*

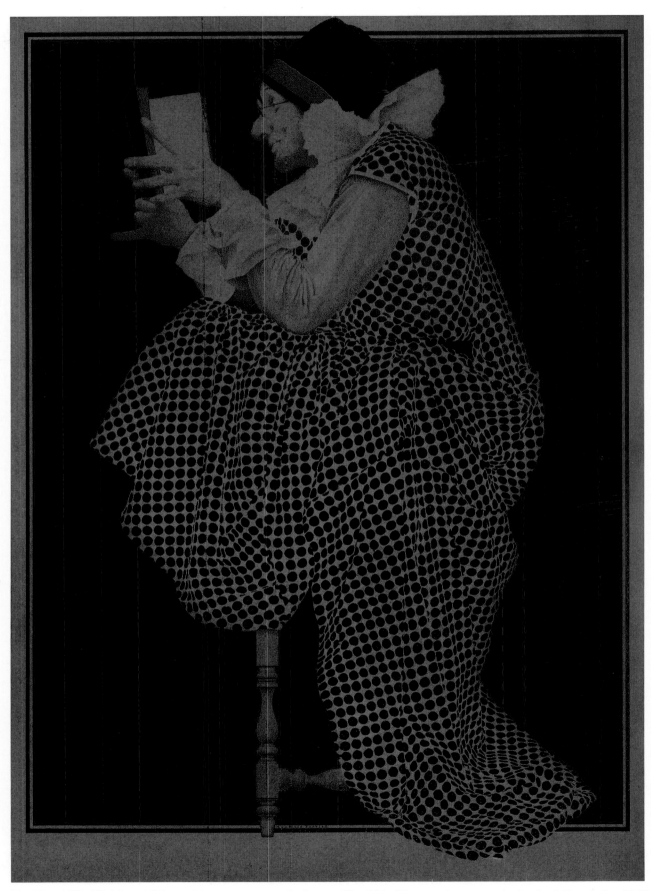

The Idiot, 1910. Oil, ink and lithographic crayon on stretched paper, 22 x 16 in. Photograph courtesy Auchenbach Foundation, M.H DeYoung Museum, San Francisco

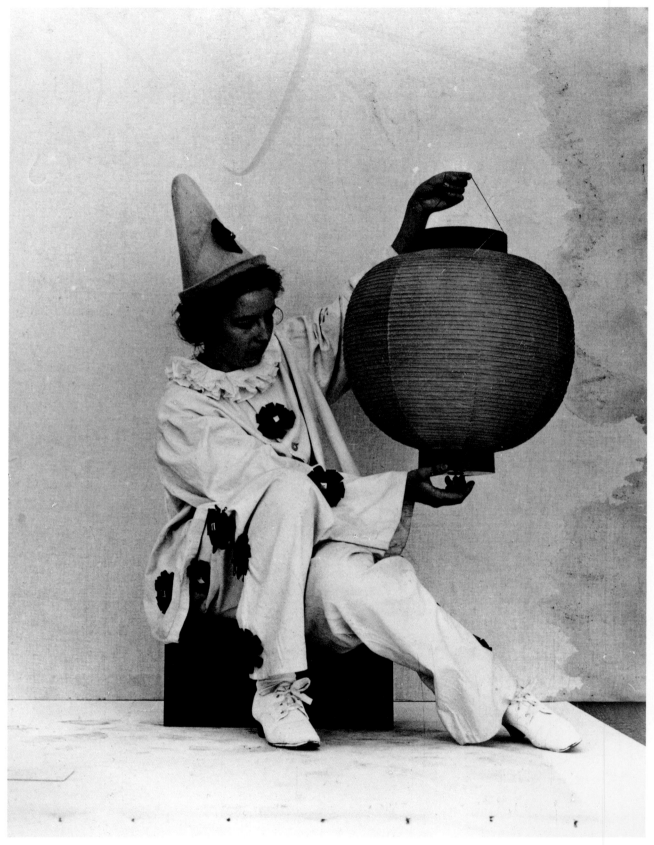

Sue Lewin posing for *The Lantern Bearers*

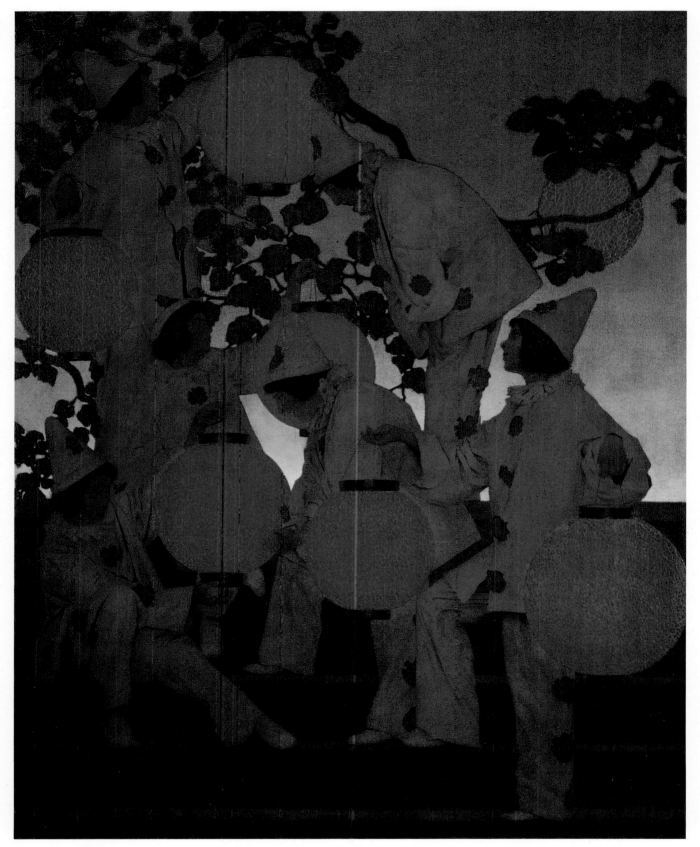

The Lantern Bearers from *Golden Treasury of Songs and Lyrics* edited by Francis Turner Polgrave (Duffield and Co., 1911)

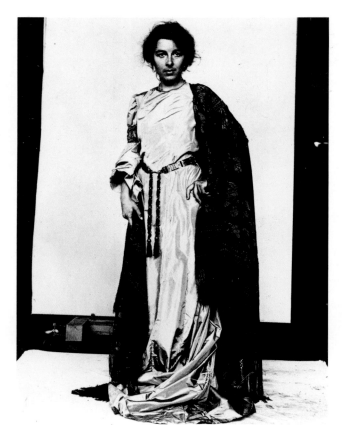

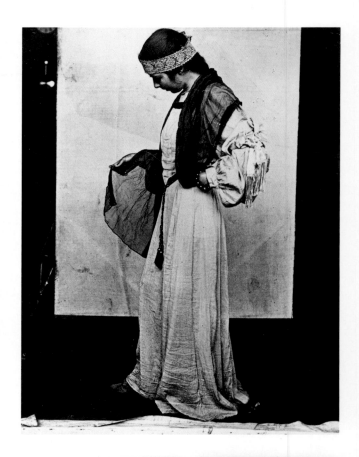

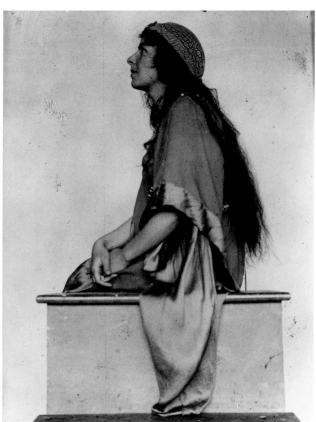

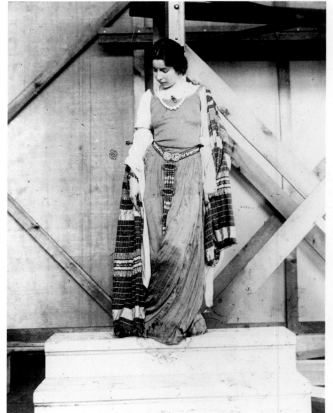

Sue Lewin posing for the *Florentine Fête* mural

The year before Parrish had been commissioned by Edward Bok, the innovative director of *Ladies Home Journal*, to execute eighteen panels for "The Girls' Dining Room" for the Curtis Publishing building. The company employed many young women and decided to build "the most beautiful dining room in America"[6] on the top floor of the building in Philadelphia.

Bok had asked Parrish to complete the murals within a year. After arriving at a figure of $2,000 per panel, Parrish sent the presentation piece for what came to be called the "Florentine Fête Mural" to Robert Seeler, the architect for the project, for approval. Parrish wrote on July 18, 1910, to Mr. Bok:

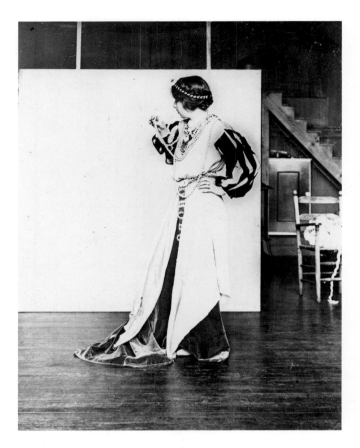

> The scene will be in white marble loggia: the foreground will be a series of wide steps extending across the entire picture leading up to three arches and supporting columns . . . It will be my aim to make it joyous, a little unreal, a good place to be in, a sort of happiness of youth . . .[7]

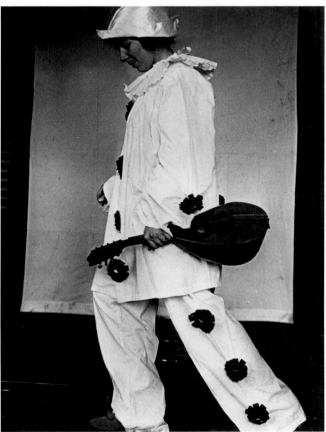

Sue Lewin posing for the *Florentine Fête* mural

Parrish asked Sue to pose for all but two of the over one hundred figures of both men and women. It was at the start of this, his biggest com-

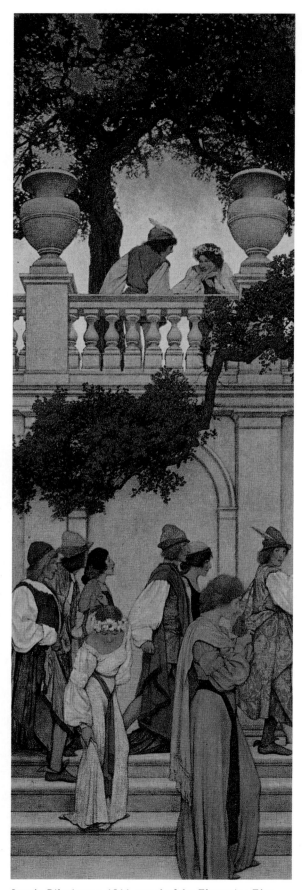

Love's Pilgrimage, 1911, panel of the *Florentine Fête* mural. Oil on canvas 10 ft. 8-1/2 in. x 3 ft. 5 in.

mission, that Parrish moved out of the big house, presumably to concentrate on the work at hand, and took what was to become permanent residence in his studio. Lydia and the children remained in the house; Sue moved into the studio with Parrish. It was also in 1911 that Lydia began to winter on Saint Simons Island, Georgia.

A year later, with the project not close to completion, (Parrish finished all but one of the panels in 1913, with the last and longest canvas panel finished in 1916), Parrish wrote again, " . . . all the people and youths and girls; nobody seems old. It may be a gathering of only young people or it may be a land where there is youth, and nobody grows old at all . . ."[8] The eighteen panels comprising the Florentine Fête composition reflect one of Parrish's most significant accomplishments.

Parrish steadfastly refused to name the panels. Perhaps he was afraid of what the names might reveal about the young woman whom he had asked to pose for all the figures, save two. (The presentation piece [Parrish later expanded it into the triptych entitled *A Garden of Opportunity*] featured the figure of an older man bearing Parrish's features as the central character in the panel later titled *A Call to Joy*. The man appears again in the flanking panel, *Love's Pilgrimage*.) The

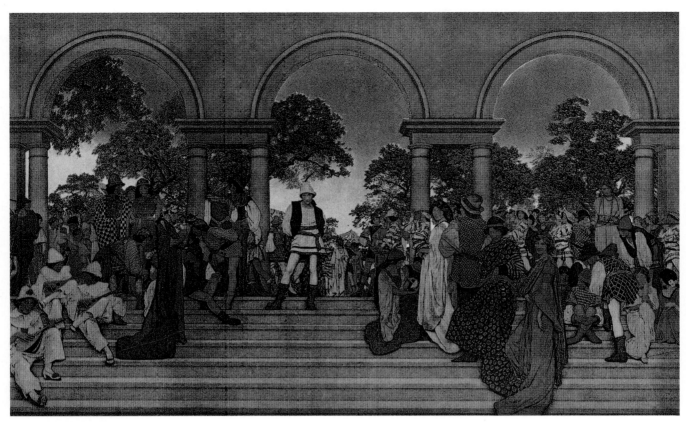

Sweet Nothings, 1912, panel of the *Florentine Fête* mural. Oil on canvas

Sue Lewin posing for the *Sweet Nothings* panel

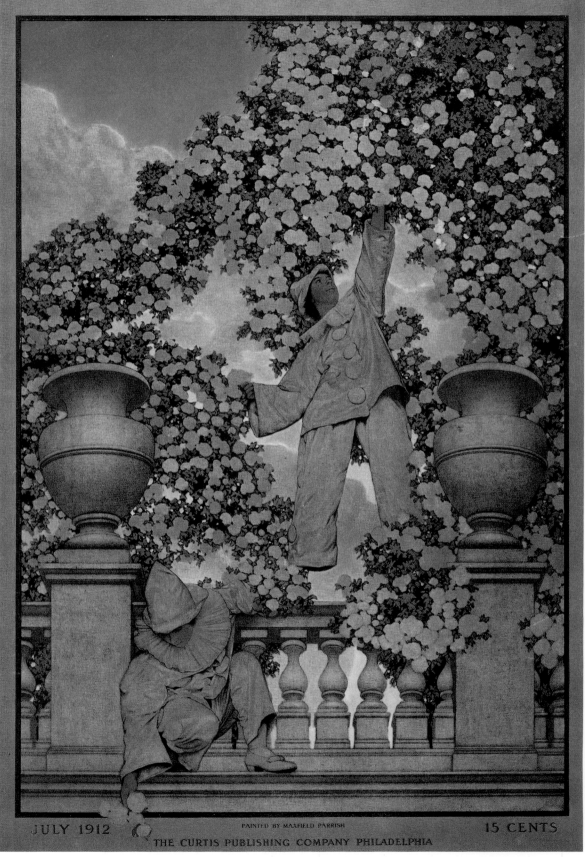

Curtis Publishing Company titled some of the other panels *Roses for Romance, The Boughs of Courtship, The Whispering Gallery, Sweet Nothings* and *The Vale of Love*. It was evident to the publishers that despite Parrish's protestations to the contrary, the panels taken in context were a very vivid and graphic demonstration of and tribute to youth and love. In anticipation of the completed panels, the *Ladies Home Journal* in 1912 touted the mural as one of Parrish's most major achievements. They informed their readers:

The paintings are ten and half feet high, and vary from three and a half to five feet in girth. There will be sixteen [*sic*] in all, and then a long painting ten and a half feet high and seventeen feet wide . . . The dining room is one hundred and seventy-six feet long, with fourteen colonial windows, most of which overlook the beautiful verdure of Independence Square. In each of the sixteen spaces alongside of these windows will fit one of Mr. Parrish's beautiful paintings, all these leading up to the main picture, at the end of the room . . . The panels are all complete in themselves, and yet each is connected with the others . . . The loggia and steps

are crowded with youths and maidens in fête costumes. All is happiness and beauty. Everyone is young. It seems to be a land where nobody is old. The whole will be a wonderfully successful result of the artist's idea to present a series of paintings that will refresh and "youthen" the spirit and yet will not tire the eye.[9]

But when Bok asked Parrish in one of his letters what the murals meant, Parrish responded:

. . . what is the meaning of it all? It doesn't mean an earthly thing, not even a ghost of an allegory. The endeavor is to present a painting which will give pleasure without tiring the intellect: something beautiful to look upon. A good place to be in. Nothing more.[10]

In his sonnets, Shakespeare left a literary trail of clues alluding to some of the loves in his life. It may be that in the Florentine Fête murals, Parrish, like Shakespeare, left clues and hints about his feelings for the young woman who had become his full-time companion. Upon close examination of the figures, most of them are wearing wedding rings. If, then, the panels show us a myraid of

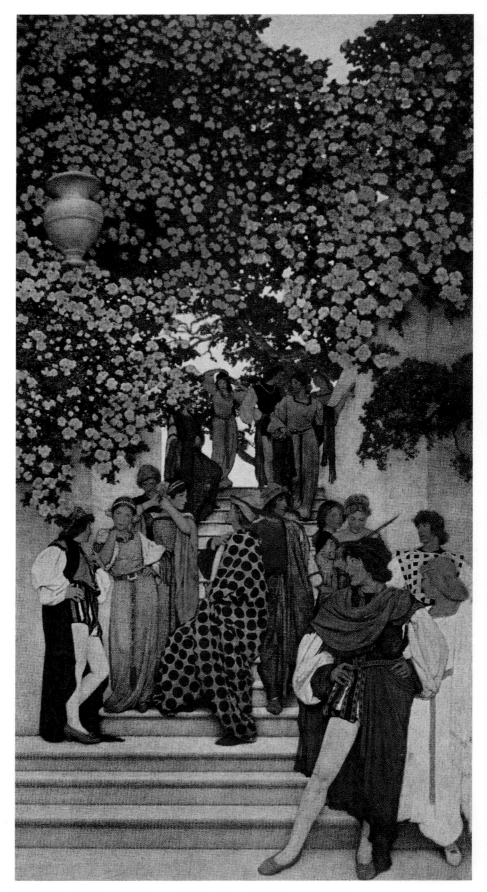

Buds Below the Roses, 1912, panel of *the Florentine Fête* mural. Oil on canvas

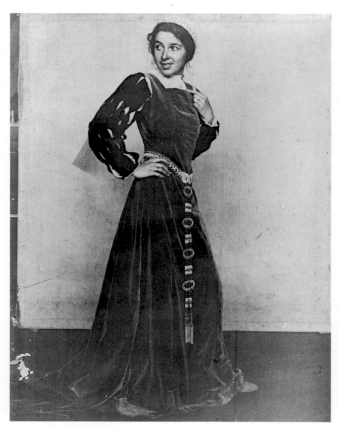

Sue posing for *Buds Below the Roses*

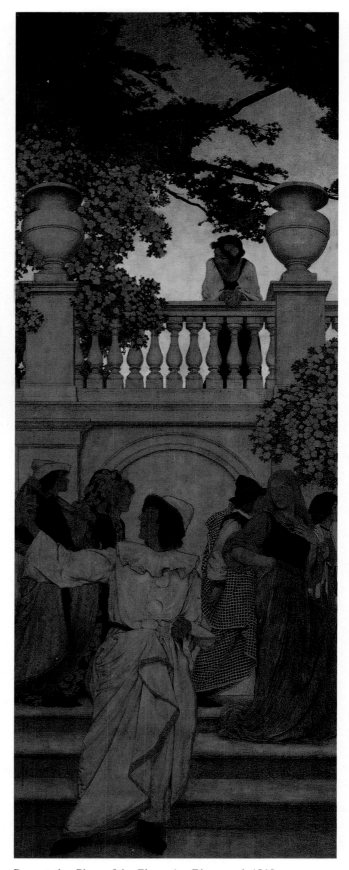

Presentation Piece of the *Florentine Fête* mural, 1910

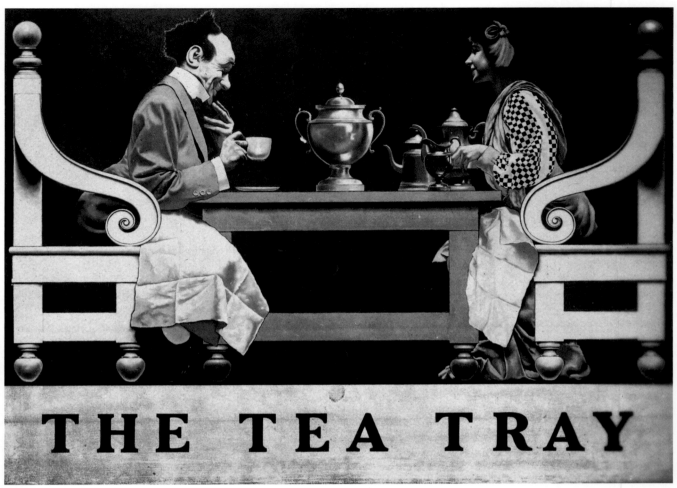

THE TEA TRAY

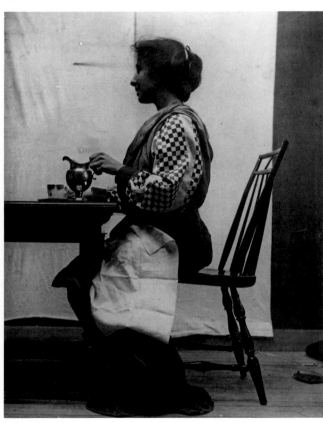

Above: *The Tea Tray*, 1914

Left: Sue Lewin posing for *The Tea Tray*

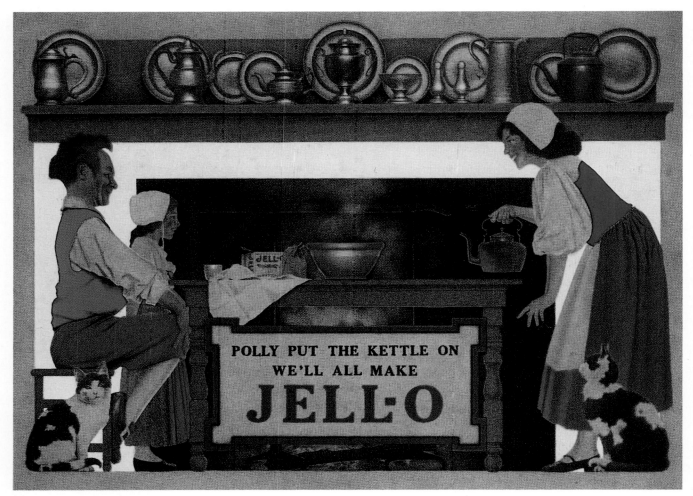

Polly Put the Kettle On and We'll All Make Jell-O, advertisement for Genessee Pure Food Company, 1921

young people in the act of courtship, it is rather provocative to find so many of them wearing wedding rings. Indeed, the characters in the panels seem to reflect one person, one woman, who was spoken for, and Sue Lewin always wore a wedding band on her left hand during her years with Parrish.

Sue Lewin was the woman who "youthened" Parrish's spirit. The Florentine Fête panels are his tribute to that wish to remain young, as embodied by the beautiful young woman who so dominated

his art and his thoughts during the midpoint of his life.

As well as modeling for the Florentine Fête murals, Sue posed for several of Parrish's commercial assignments. Because Parrish enjoyed her daily teatime ceremony so much, Sue was the obvious choice to model with George Ruggles for *The Tea Tray*, a signboard designed in 1914 by Parrish for a friend's tea house on the Cornish Road. Sue's cooking abilities inspired the painting for Jello, *Polly Put the Kettle On*, as well as

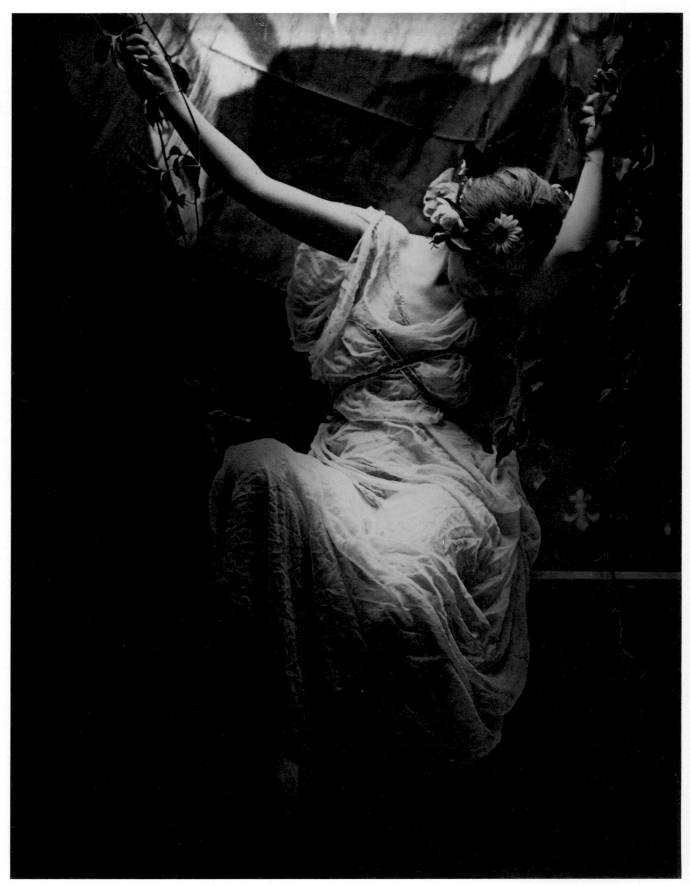

Sue Lewin posing for "Reveries" (unpublished Hearst cover), 1913.

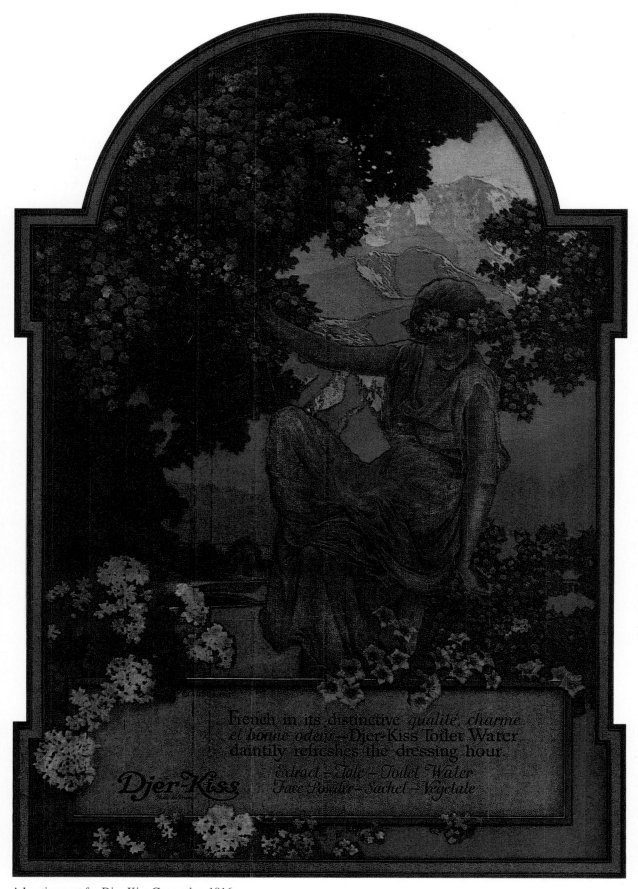

Advertisement for Djer-Kiss Cosmetics, 1916

The Rubaiyat, illustration for Crane's chocolates candy box cover, 1916

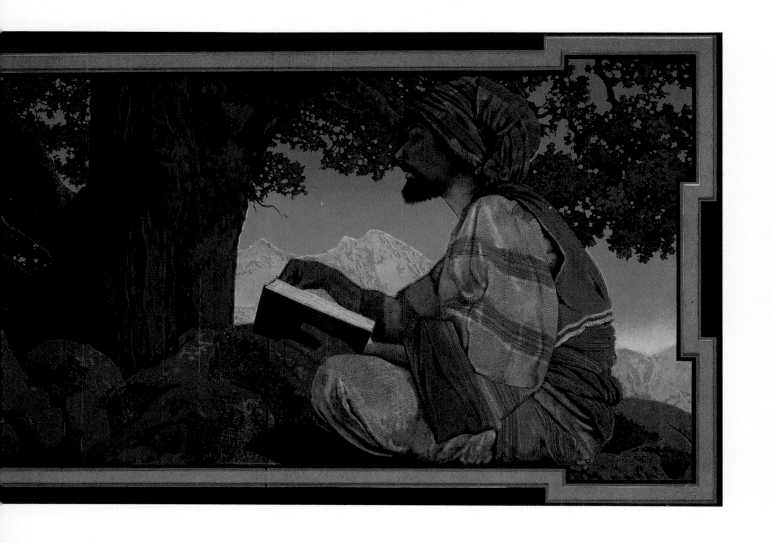

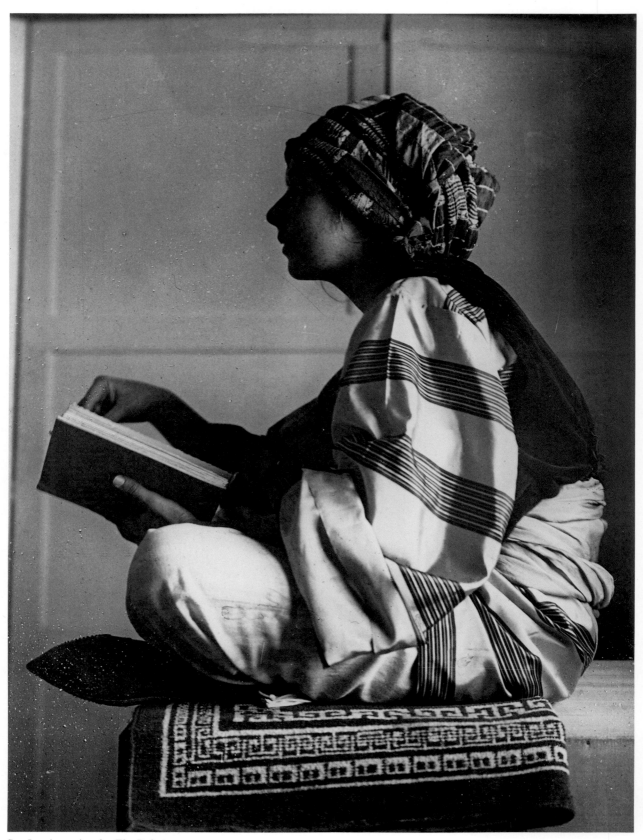

Sue Lewin posing for *The Rubaiyat*

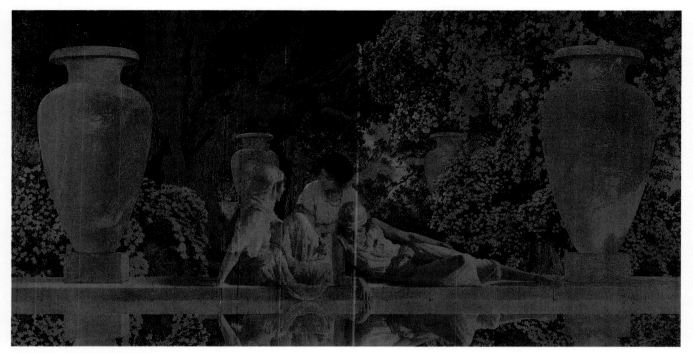

Garden of Allah, 1918. Oil on masonite, 15 x 30

the cover drawing Parrish made for her cookbook, *The Little Chef.* In 1916 she posed for two very successful advertisements, *Djer Kiss,* for a perfume company, and *Rubaiyat*, for the cover of a box of Crane's chocolates.

Sue posed for both the male and female figures in *Rubaiyat*. This advertisement was so successful that Parrish was commissioned again by Crane's in 1918 for another gift box. The result-ing *Garden of Allah* became one of his three most important paintings, and it features Sue by his swimming pool, gazing into the water. (*Garden of Allah* was also issued as a reproduction by House of Art in 1918.)

In Sue, Parrish found not only a tractable and attractive companion, but also someone whose face, figure and talent for design complemented his work perfectly.

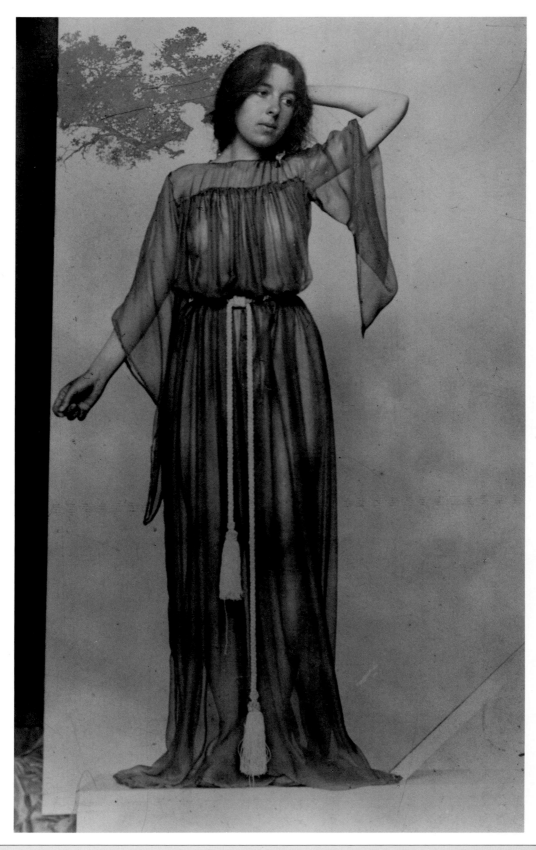

Sue Lewin, 1916

Chapter Five
EXPOSED

*I*n September of 1918 Parrish moved into the New York apartment at 75 East 81st Street to be near the progressive Teacher's College, where his older boys were enrolled for formal education. At the time, Sue was modeling for him for a commercial assignment for Ferry Seeds, and Parrish asked her to accompany him. They lived together there for about nine months, when they returned to The Oaks.

Parrish carefully guarded his privacy and his relationship with Sue, steadfastly stone-walling any inquiries into his personal life. Aside from the obvious reasons for protecting himself against any inquiries into his relationship with Sue, he was surely motivated by a prior family scandal to shield himself and Sue from the public eye. His mother, Elizabeth Bancroft Parrish, had left his father in 1898 (she later joined a commune in California), and the community's shock and outrage was not something Parrish cared to relive. (Stephen Parrish wrote in his diary on August 22,

1898, "E.B.P. left for Philadelphia today with a nurse," and then on March 1, 1903, "E.B.P. will not return to Cornish."[11]) In fact, Parrish's nervous breakdown occured during these years of his mother's departure.

Sue supported Parrish's guarded responses; "I'll have you know that Mr. Parrish has never seen my bare knee"[12] was her answer to a prying inquiry. But evidence has made it clear that Sue was not telling the truth, for Parrish posed Sue for the nude photograph he used to create the Mazda Lamp calendar painting *Primitive Man* in 1920. Although he was very careful to hide the glass slide in a secret compartment of his darkroom, it was discovered, years after his death, when an alarm system was being installed in the studio during its conversion into a museum.

Lydia Parrish, however, could not ignore the relationship her husband was cultivating with a woman nineteen years his junior. Around 1921, when Mazda Lamp reproduced *Primitive Man*,

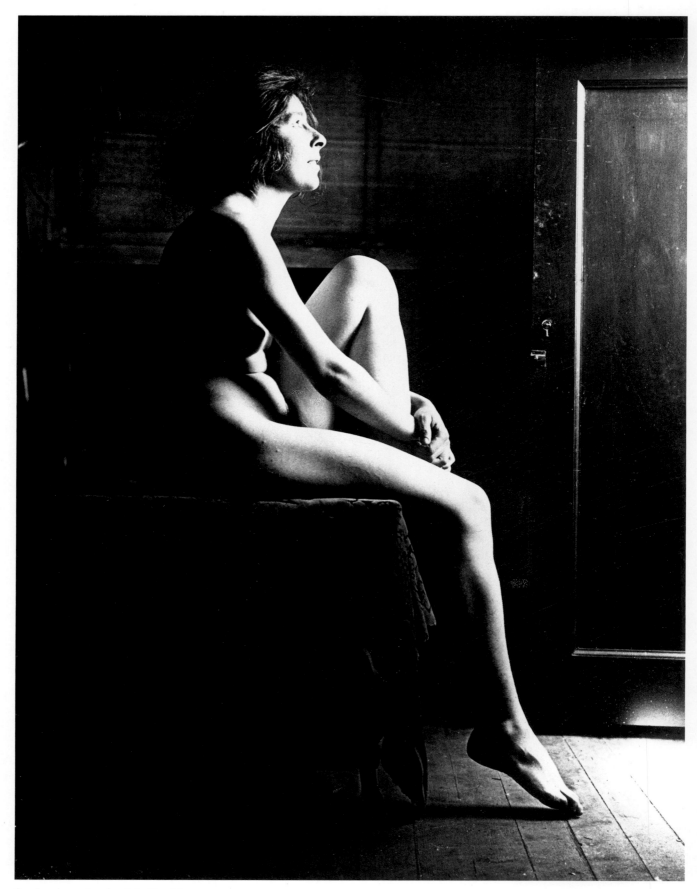

Sue Lewin posing for *Primitive Man*

Primitive Man, 1920. Oil on panel

Lydia began showing strain. She confided to Mabel Churchill her decision to leave her husband. Both Churchills approached Parrish and convinced him that Sue's continued presence in the studio had severely threatened his marriage with Lydia. Being absolutely phobic about scandal and the underlying publicity, the Parrishes decided to attempt a discreet trail separation. In the summer of 1921 Lydia left for Europe with the Churchills, and Sue moved into the Churchill's palatial mansion, Harlakenden.

Fate was to interfere with the good intentions of the parties concerned. Late one evening Parrish received a frantic phone call from Sue. Harlakenden was on fire and burning rapidly. Parrish was the first man to reach the burning home of his friends. He and the neighbors fought the blaze gallantly, but to no avail. Harlakenden burned to the ground in hours.

Parrish brought Sue back to The Oaks, establishing her residence in the studio once again. She would continue to live there for another forty years. When Lydia returned from Europe, she was faced with the reality that if she wanted to pretend to the children and the community that all was well, and if she wanted to maintain her lifestyle of writing, traveling and entertaining the wealthy and famous visitors who came to The Oaks, she had to live with the status quo of her husband's relationship with Sue Lewin.

She must have accepted the situation with a great deal of reluctance, yet she maintained a polite, stoic behavior. She continued to treat Sue as simply someone employed on the property, and the two women maintained a polite, but reserved demeanor when together. Sue lived with Parrish in the studio; Lydia stayed a stone's throw away from them across the manicured lawn in the big house.

The Cornish community did not allow this arrangement to continue unnoticed. Once a delegation of townspeople came to The Oaks to speak to Parrish about the "unseemly arrangement" of his living with Sue. Parrish immediately escorted them off his property. Although publicly both Parrish and Sue denied and were offended by the townspeople's accusations, Warren Westgate maintained that Sue confided in a number of people about her love for Parrish.

As the years progressed, Sue and Lydia maintained the truce. Outwardly each presented to the world an impeccable facade. No impropriety was admitted, and the Parrish children were carefully protected from any hint of scandal.

Many years later, when Dillwyn and Max-

Lydia in her garden, 1912

field, Jr. were adults, Max wrote to his brother, "I talked to your shrink the other day. He asked me how I had felt about Dad's 'mistress.' What mis-tress? Susan? I never thought of it, but of course, she must have been! Mother certainly never men-tioned it."[13]

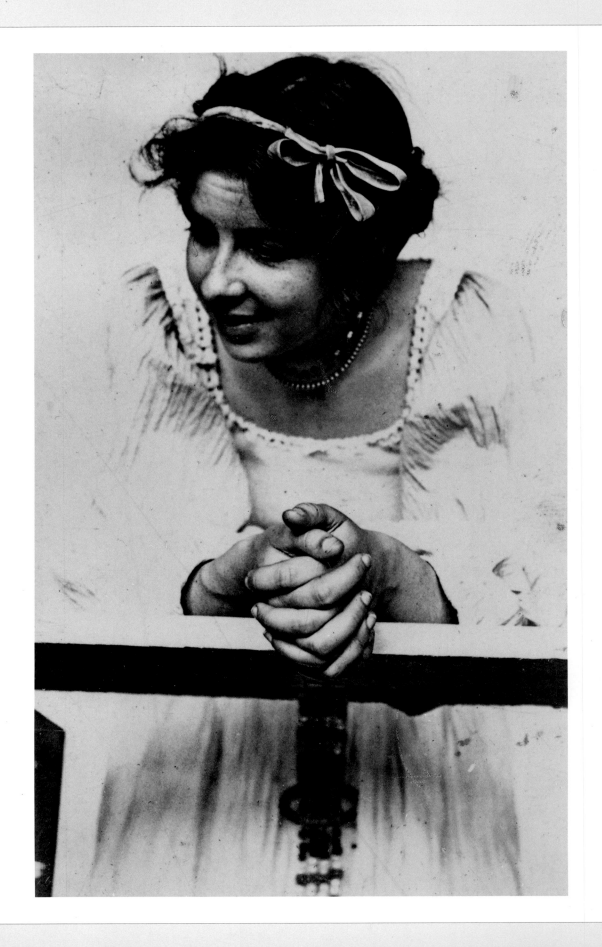

Chapter Six
SUE LEWIN IMMORTALIZED

The 1920s brought to Parrish new and life-lasting fame and fortune. The decade spawned many of his greatest paintings, including *Daybreak* (1922), *Canyon* (1923), *Wild Geese* (1924) and *Enchantment* (1926).

Daybreak became the decorating sensation of the 1920s. The commercial print published by The House of Art became an instant global success. There were millions of copies printed, and, in short order, Parrish became the most reproduced artist in history. His royalties would exceed $75,000 in 1923 alone. In 1925 the Scott and Fowler Gallery in New York established a precedent for all future Parrish shows by selling every painting in his one-man show. *Daybreak, Romance* and *Garden of Allah* each fetched the princely sum of $10,000.

Throughout the1920s Parrish continued to pose Sue for major commissions. She appears in *The Lute Players* (1922), which originally was to be a design for a mural for the Eastman Theatre

in Rochester, New York. The House of Art published reproductions of this painting in two versions (with royalties split between Parrish and the Eastman Theatre); one reproduced the painting faithfully in its vertical format, but the other was a horizontal edition that eliminated the trees and blue sky.

In addition to *Primitive Man* (1920), Sue posed for other Mazda Lamp calendars, including *Lamp Sellers of Baghdad* (1923), *Venetian Lamplighter* (1924) and *Dreamlight* (1925).

In the annals of children's book illustrations Parrish would immortalize Sue by using her as the model for Lady Violetta, Ursula and the Knave, all characters in the beloved children's book by Edith Saunders, *The Knave of Hearts*. To this day, this book, in its original edition, remains the most valuable of all the Parrish illustrated books, perhaps because of his rich depiction of Sue as the various protagonists of the story.

This decade also marked the end of Sue's

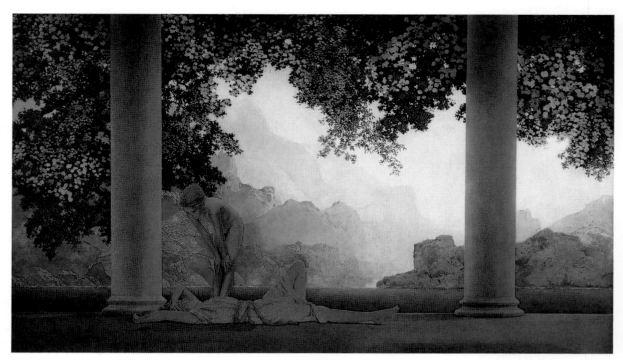

Daybreak, 1922. Oil on Masonite, 26 x 45 in.

career as Parrish's primary model (by 1925 Sue was thirty-six years old). The process began with *Daybreak*. While Sue posed for the reclining figure, Parrish superimposed the facial figures of Kitty Owen, the granddaughter of William Jennings Bryant and a classmate of Parrish's youngest child, Jean. (The nude, nubile youngster leaning over the Sue/Kitty figure was posed for by Jean.) Kitty continued to model for Parrish in *Canyon, Wild Geese* and *Enchantment*.

The last painting for which Sue posed seems to be the unpublished piece *The Enchanted Prince* (1934), although the final model for the painting was Kathleen Philbrick Read. In it, the beautiful young woman contemplates the frog in front of her, while the frog puzzles:

> If I were to have but a kiss from this youthful maiden, I would cease to be a frog and return to my rightful state of being a prince. Alas, alack, I need her youth's love and her maiden's caress to break the spell of loneliness...."[14]

Parrish never sold the painting; he gave it to Sue instead, perhaps to let her know that she was the youthful maiden who had dissipated his loneliness and returned him to rule over some enchanted kingdom.

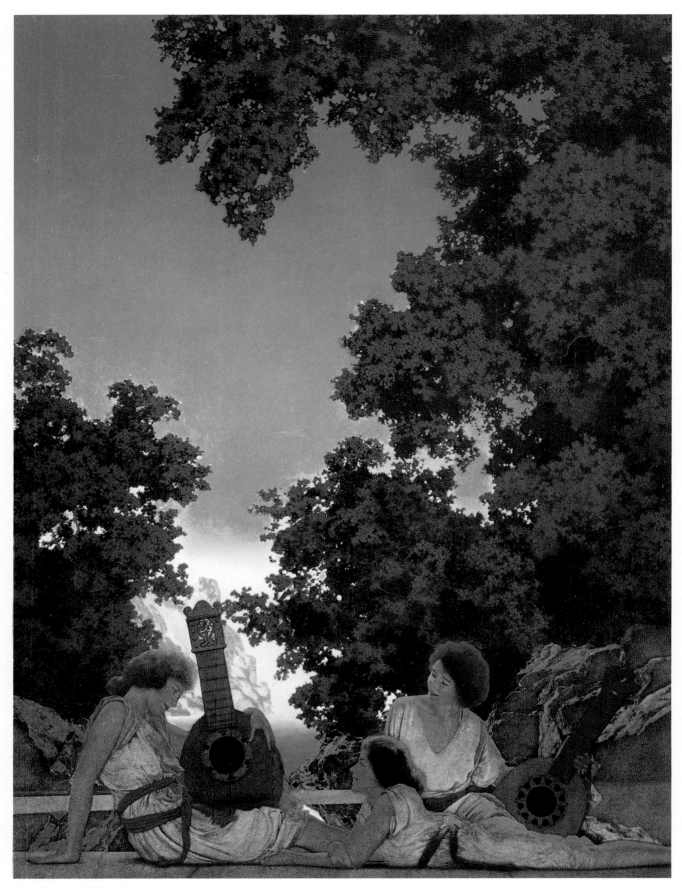

Lute Players, 1922

Sue Lewin posing for *Knave of Hearts* bookplate

THIS IS THE BOOK OF

Bookplate of the *Knave of Hearts*

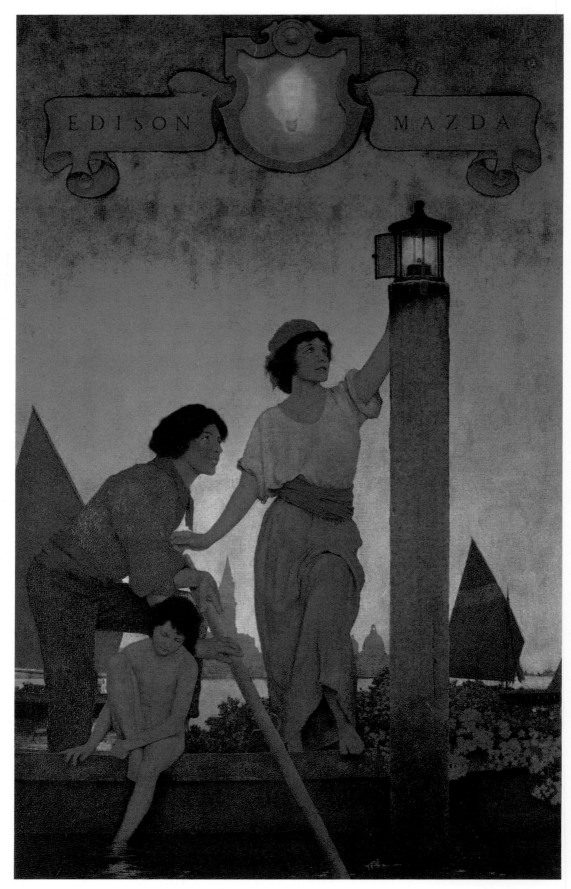

Venetian Lamplighter, 1922. Oil on masonite, 28 x 18 in.

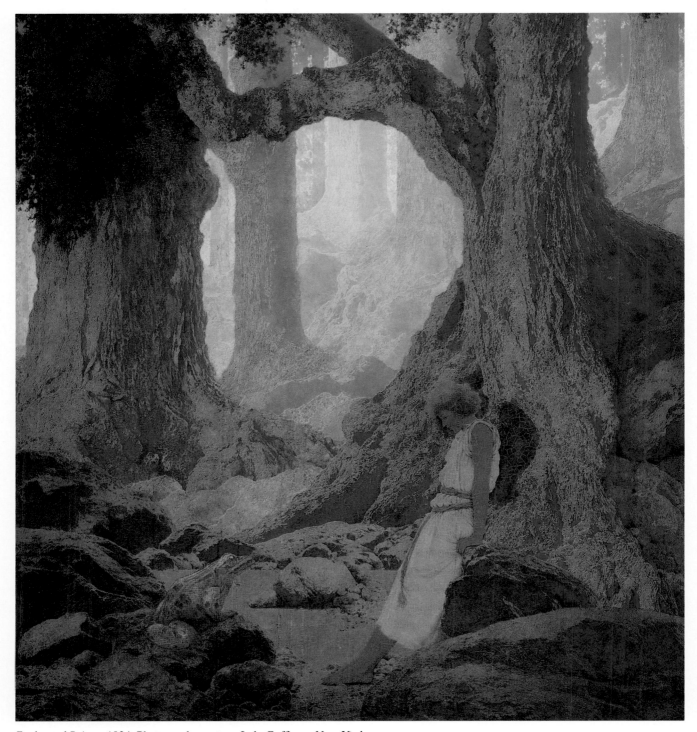

Enchanted Prince, 1934. Photograph courtesy Judy Goffman, New York

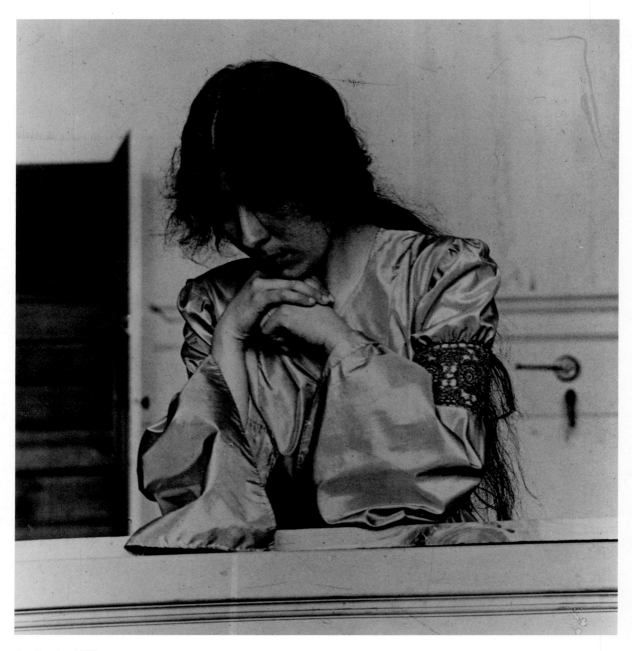

Sue Lewin, 1912

Chapter Seven
THE LATER YEARS

With few exceptions such as *The Enchanted Prince, Jack Frost* (1936) and *Two Cooks Making a Pudding* (1936) (the latter two were both covers for Colliers), Parrish's works from 1930 to 1960 were almost exclusively landscapes (perhaps because Sue no longer could pose for youthful figures) that he created for his own enjoyment and for Brown and Bigelow calendars. This was a quiet period of his life. Lydia was away most of the time, and his children were grown and married. Parrish and Sue had The Oaks largely to themselves. Sue became the arbiter of his social life in the studio; she decided who could see him and who couldn't. She maintained an air of courtesy and hospitality to all visitors, but she guarded Parrish's privacy jealously and saw to it that he was not disturbed when he was painting.

Parrish shunned publicity quite arduously. When M. K. Wisehart interviewed Parrish for American Magazine, he asked him about Sue:

Here I started to tell Mr. Parrish one or two intimate things I had heard from other sources. "Wait! Stop!" he cried. . . ."Surely you've already told me more things than it's advisable for the reader to know."[15]

When Brown and Bigelow suggested that they send a freelance writer to Cornish to interview him, Parrish would have no part of it. He wrote them in 1943:

There is nothing I dislike more than any kind of personal publicity, the so-called write-up or "story." I've endured the torture for the past forty years and have only allowed it once in awhile just to be decent, and now in my old age am thankful that there seems to be an end of it . . . If you're going in for interesting publicity, give the people mystery. The Greta Garbo kind is the very best, and it keeps up . . . I am happier in my work for

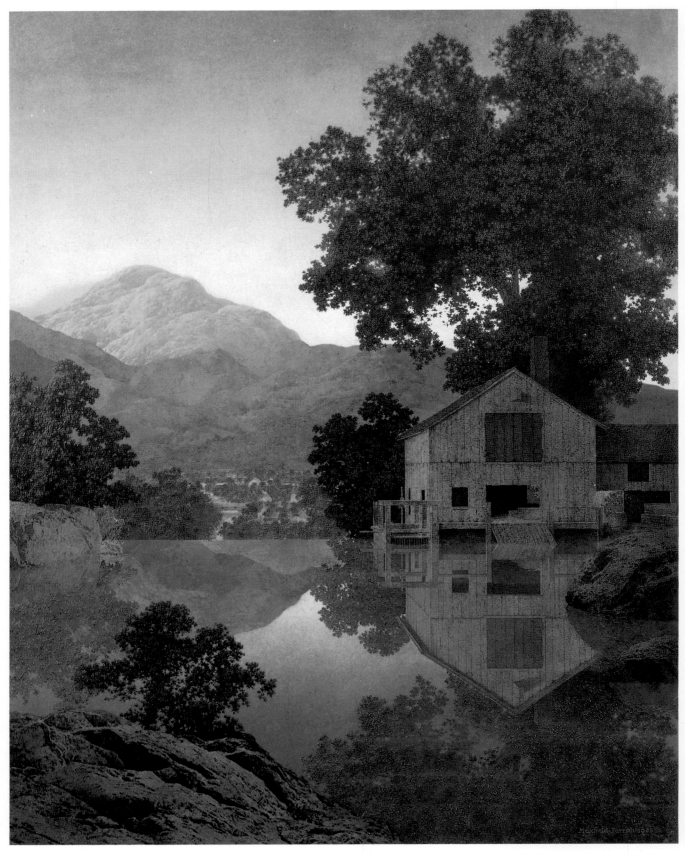

The Mill Pond, 1945. Oil on masonite, 22-1/2 x 18 in.

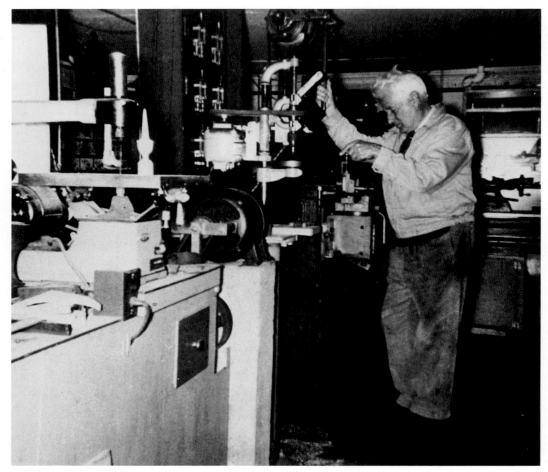

Parrish in his machine shop

you people than I have ever been, but if this publicity by-product has to be a part of it, it detracts a lot.[16]

Parrish remained tranquil and happy at his beloved home, The Oaks. He continued to paint during the mornings, putter in his machine shop and garden in the afternoons. He drove Sue to town for her errands. In a letter to J. H. Chapin, a long-time editor friend at Scribner's, he wrote on the theme of aging:

Strange what keeps us going, isn't it, or did you ever take time enough to speculate? Seems as though, for all the yesterdays are very much alike, it is the chronic curiosity of what tomorrow may have to offer. And, as a matter of fact, what more could one ask? I haven't a grey hair yet, the chief reason being that they are all pure white. And yet it is interesting to be alive and think of things; to take delight in the trivial qualities of the material world around you, having discovered long ago that you don't have to go far afield to get it. I sometimes think the dawn of a new day, the magic silence of mid-winter is

Maxfield Parrish with his four children, 1922

about all there is, and however that may perhaps be, it is good to know no better.[17]

Lydia Parrish had continued to visit St. Simons Island annually ever since her first trip there in 1912. She purchased a cottage and some land in an area of the island known as Bloody Marsh and became engrossed in researching the songs of the black inhabitants of the island. She sponsored "plantation sings" and invited the black residents to sing and perform the dances of their ancestors. Her book, *Slave Songs of the Georgia Sea Island*, published in 1942, is a compilation of the songs she recorded.

In the earlier years, the Parrish children occasionally had accompanied their mother to Georgia. Usually, however, they had preferred to spend their winters at home with their father, Sue and their governesses. Dillwyn was the exception. His mother felt that her first-born suffered from delicate and fragile health, so she always kept a close and watchful eye on him. (She was always more anxious about his childhood illnesses that she was of the others'.) Dillwyn drew closer to his mother and sometimes traveled with

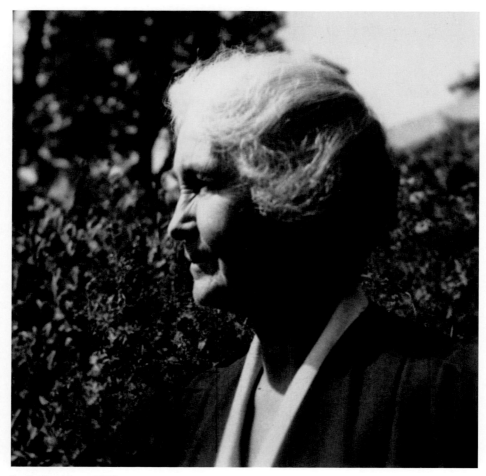

Lydia Parrish, c. 1950

her when his heartier and healthier brothers and sister opted for the carefree, unstructured living of The Oaks. The more she distanced herself from Parrish, the more Lydia became dependent on Dillwyn.

Dillwyn, who was a youthful replica of Maxfield, never really could compete in the footsteps of such a giant of a father. Dillwyn's reputation as a spoiled and pampered member of the aristocratic wealthy American family followed him throughout his life. Pretty women, hard drinking, a penchant for fast cars and a decided repugnance

to holding down a job were probably a direct result of his mother's overindulgence and transferral of affections when her marriage to Parrish became a marriage in name only.

On March 29, 1953, three years after her famous husband had received the accolades of the art world for his exhibit at the Saint Gaudens Memorial in Cornish, Lydia Parrish died alone of cancer in her home at Saint Simons Island and was buried there. Maxfield Parrish was 83 at the time. He and Lydia had been married for almost fifty-eight years.

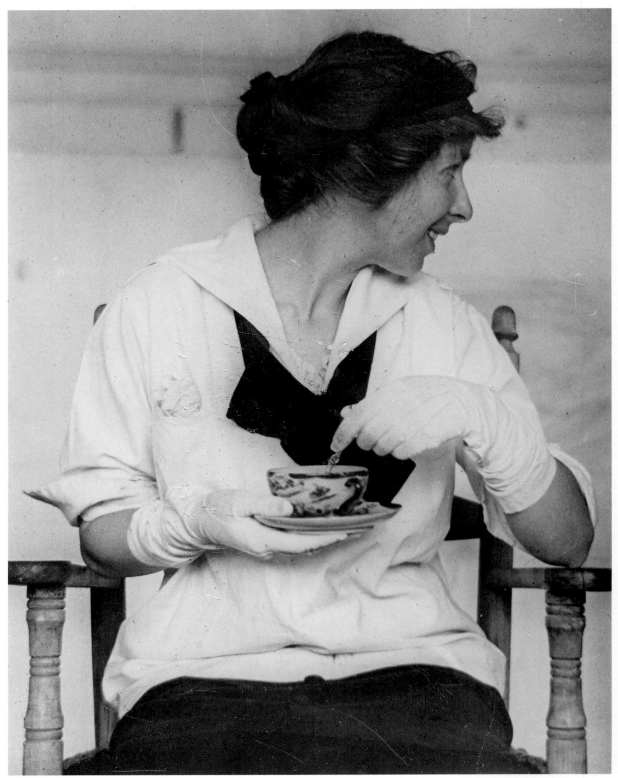

Sue Lewin, 1914

Chapter Eight
THE END OF MAKE-BELIEVE

Maxfield Parrish did not ask Sue Lewin, his companion of almost fifty-five years, to marry him after Lydia's death. Sue waited patiently for seven more years, and then, when she realized that there would be no formalization of their life together, she left The Oaks and Parrish to marry Earl Colby, one of her childhood sweethearts and an early suitor at The Oaks. It was 1960, and Sue was 71 years old; Maxfield Parrish was 90.

Perhaps Parrish believed that desirable relationships didn't work in the context of marriage. After all, he had for examples his father's marriage as well as his own. Much as he cared for Sue, Parrish may have felt that this would not be a marriage of equals, given their disparate social strata. Perhaps he was concerned about diminishing his children's estate if he took another wife, and he still may have wanted to avoid scandal and disapproval. Finally, marriage would have

admitted relationship that both he and Sue denied had ever existed.

On October 10, 1960, shortly after Sue's marriage to Earl Colby, Parrish presented himself at the Windsor office of his attorney, Effinham Evarts, to rewrite his will. The will on file at the New Hampshire probate court reads in part:

LAST WILL AND TESTAMENT

I, Maxfield Parrish, of the Town of Plainfield, County of Sullivan, State of New Hampshire, being of sound and disposing mind and memory, do hereby make, publish and declare this to be my LAST WILL AND TESTAMENT:

FIRST: I direct that all my just debts and funeral and testamentary expenses be paid as soon as possible after my death.

SECOND: I give and bequeath to SUSAN LEWIN COLBY the sum of Three Thousand

Maxfield Parrish, c. 1964

Dollars ($3,000) and direct that any inheritance, estate, death, succession or other tax imposed by the Federal Government or any State Government on this bequest be paid out of my residuary estate . . .

The will goes on to list his children and cousin Anne Parrish as the other inheritors, with a precise listing of his stocks, real property and some ancestral furnishings.

It is interesting that the first person named in Parrish's will was Sue, already being addressed by her new married name. That she is the initial person named invites speculation that the terms of her inheritance were the main reason for a new will. The sum of $3,000 seems a paltry sum for someone who had been Parrish's devoted companion for fifty-five years. Had former wills assigned more property to her? Was Parrish getting revenge for her marrying Earl Colby? Or was he keeping Sue "in her place" as a member of his staff with a token sum for a lifetime of service, a continuing ploy to deny that their relationship was intimate? Perhaps former wills assigned

nothing to Sue, and since Sue had married, Parrish felt it was "safe" to leave her something. Or did Parrish, empassioned by his love for her, commit his bravest act in their life together by acknowledging her in his will at all? There are many unanswered questions.

Whatever Parrish's motivation for his will, he and Sue visited occasionally after her marriage, and when she and Colby traveled together to Florida, she and Parrish continued to correspond regularly. In one of his last letters to her, Parrish signed it, "With words unutterable . . . M. P.," a phrase that seems to encapsulate their life together.

Maxfield Parrish stopped painting in 1961 at the age of 91. His last work, a small landscape titled *Away from it All*, shows a small house on a snowy moonlit hill, one small light burning hopefully in the window. He lived long enough to see the beginning of a major revival of interest in his work among a new generation of Americans. In the early '60s the first of several major retrospective exhibitions of his paintings was organized at Bennington College. When the exhibition traveled to the Gallery of Modern Art in New York, Parrish asked in an interview in Time, "How can these avant garde people get any fun out of my work? I'm hopelessly commonplace."[18]

Parrish c.1954

Back of the main house as viewed from the studio

For the last years of his life from 1964 to 1966, Parrish employed a live-in nurse. He refused to be moved from The Oaks. On March 30, 1966, he died quietly. He passed away on a lovely early spring day, with crocuses pushing their heads bravely through the vestiges of a late snowfall and the sky tinged with the lovely palette he was so fond of depicting. It was as if nature itself were bidding a salute to one who had enjoyed painting it so thoroughly.

The magnificent main house at The Oaks was destroyed by fire thirteen years later in 1979.

The poet Sylvia Tryon, after viewing an exhibit of Parrish paintings in Boston's Vose Galleries in 1963, wrote Parrish the following poem:

TO MAXFIELD PARRISH

How falls it, painter, that your brushes dye
In blaze of sapphire our pale northern sky,
Kindling on sunsmit peaks a lucent forge,
Robing in azure mists each gulf and gorge?
In long forgotten ages, did your soul
Make gorgeous Italy its homeward goal?
Or in some former earth-time did your mind
On Athens' violet hills its temple find?
Or where through frozen, silent arctic nights
In flaming aureole stream the elfin lights?

On granite rocks your colors play like morn,

As on Ionian marble rosed with dawn,

In our drab lives should such hues tinge the day,

We scarce could deem ourselves of common clay.[19]

Parrish responded with a verse of his own:

TO SYLVIA TRYON

How comes it, poet, that you fail to see

About you lovely colors blamed on me?

Of course it's hard, in all the dirt and grime,

To single out the things that are sublime,

But I do claim, that, hung up there to dry,

The family wash against the evening sky,

Is just as beautiful in mystery

As Grecian temples famed in history.

We just don't chance to see it, more's the pity —

There's so much else in our big city.[20]

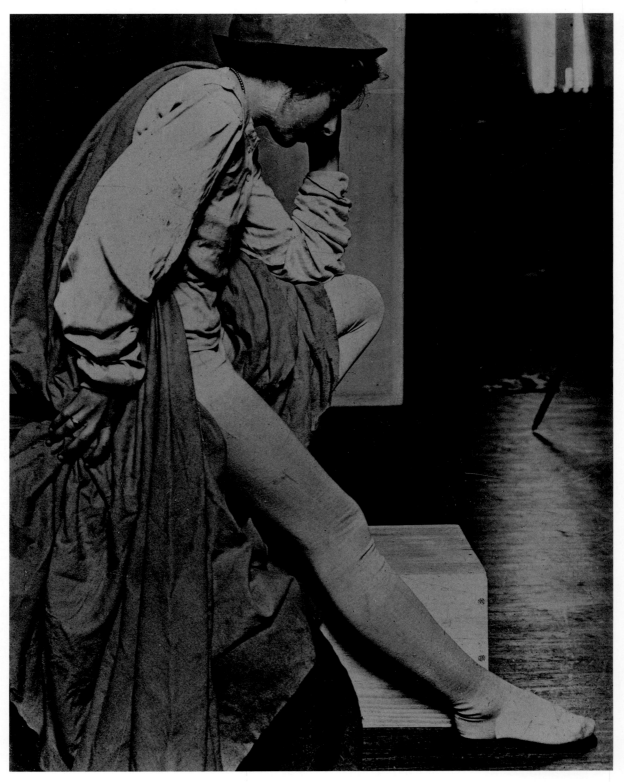

Sue Lewin, 1925

Epilogue
A LATTER DAY GRISELDA

When I first bought The Oaks in 1978 and converted the studio into a Parrish museum, one of the overriding puzzles in my mind was the relationship between Maxfield Parrish and Sue Lewin. No one wanted to talk about it, and no one had ever written about it. The definitive biography of Parrish, *Maxfield Parrish* by Coy Ludwig (Watson Guptill, 1973), contains only a one-sentence mention of Sue.

My curiosity was piqued. The more I hungered for information, the more the paintings themselves seemed to hold the key to the puzzle.

The first painting for which she posed, *The Land of Make Believe*, seemed to represent Sue as the young heroine of a fairytale. She had entered Parrish's life as a poor serving girl, and as in all good fairytales, she probably expected that her constancy and devotion would eventually earn her a rightful place by her "enchanted prince." But the one portrait that seems to hold the greatest clue is *Griselda* for which Sue posed in 1909. Griselda (which means "the patient one") is the heroine of the final tale of Boccaccio's *Decameron*. Grisdelda's husband, the Marquis di Saluzzo, chooses her from among the peasantry because of her youth and beauty, then decides to test her fidelity. The Marquis feigns boredom and pretends he has married again. Turned out of the house, Griselda endures her sufferings nobly and remains constant for years until Saluzzo relents. She is then restored to her home and children having won the love and admiration of her husband and his people.

Parrish often referred to Sue as "the faithful Susan." Certainly her test of constancy and fidelity rivals that of Griselda's. For Maxfield Parrish's

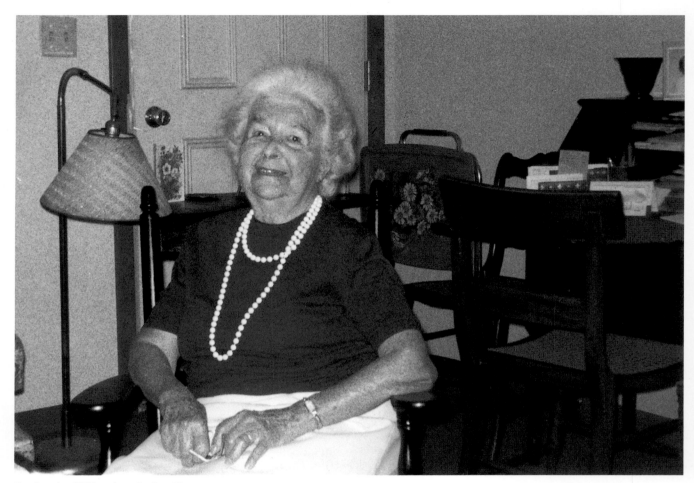

Sue Lewin, 1970s, photo by Les Ferry

depiction of Boccaccio's Griselda, he chose his own exemplary model of patience.

Royal Cortissoz, a reviewer for the New York Herald Tribune, once wrote about Parrish's paintings:

> His art is a curious phenomenon. It stands alone and has charm, yet it is as unimpassioned as a photograph. His technique produces results that reflect a quality of detach-

ment and objectivity even when the subject was a very personal one. [21]

Susan Lewin, the subject of so many of Maxfield Parrish's paintings, was immortalized in them in disguise, in costume. Parrish's only method of publicly honoring her, of expressing his love for her, was to use her image in his work. He never broke free from the constraints of the objectivity and detachment of his paintings, or

the dispassionate relationship with his wife. He could never face up to the harsh judgements of his peers to proclaim his love for his Griselda.

I had the pleasure of meeting Sue Lewin Colby in October, 1977, three months prior to her death. She had learned of my intentions to purchase The Oaks and to establish a Maxfield Parrish museum. She wrote me a note inviting me to tea, and I was delighted to oblige.

When I met her that lovely fall afternoon, Sue was a widow. Earl Colby had passed away in 1968, and she was living in a house in Claremont left to her by her aunt, Grace Westgate French. Her husband's property had gone to his children by a former marriage. We sat in her immaculately clean, small parlor, surrounded by photographs and mementos of Parrish, the man she had served and loved for so many years. The brilliant hues of the New England autumn filled the room. As she sat, comfortable and poised in the middle of the room, her face and demeanor belied her eighty-eight years. Her snow white hair framed a charming, grandmotherly face with little or no wrinkles to mar the still perfect symmetry of her features.

Sue listened intently when I talked to her of my plans for the museum, including the oral histories I hoped to compile and the exhibits of paintings, writings and photographs I planned to present. She mentioned that she had a number of Parrish's glass slides taken of her posing for various paintings, and I asked if I could see them sometime. She nodded and promised to look for them for me.

Because it was my first meeting with Sue Lewin, I could not bring up the subject of her relationship with Parrish without imposing on her hospitality. Her references to him were very deferential and circumspect. I kept thinking as I chatted with her that we were discussing someone with whom she had lived for almost sixty years, and yet she referred to him as "Mr. Parrish." But there was pride in her voice as she talked about him, her unspoken love shining and evident before me.

When I left her that afternoon, I had already promised myself that one day I would write the untold love story of Maxfield Parrish and Sue Lewin.

Susan Lewin Colby died January 27, 1978. She was cremated and was interred that spring in the Plainfield cemetary alongside Earl Colby's grave. I attended her funeral service thinking about my meeting with her a few months before.

Would it have been more fitting for her to have been buried next to the ashes of the man she had loved nearly sixty years? Maxfield Parrish's paintings bearing her face and features will forever reveal his hidden love for her. Her immortality is assured. For me, she will always be the young sixteen year old, posing for *The Land of Make Believe*, posed at the brink of the larger-than-life "land of make-believe," which she entered and where she stayed as the love and inspiration of Maxfield Parrish's life.

"Griselda is dead,

and eek her patience and fidelity

and both at once buried in Italie"

— Chaucer

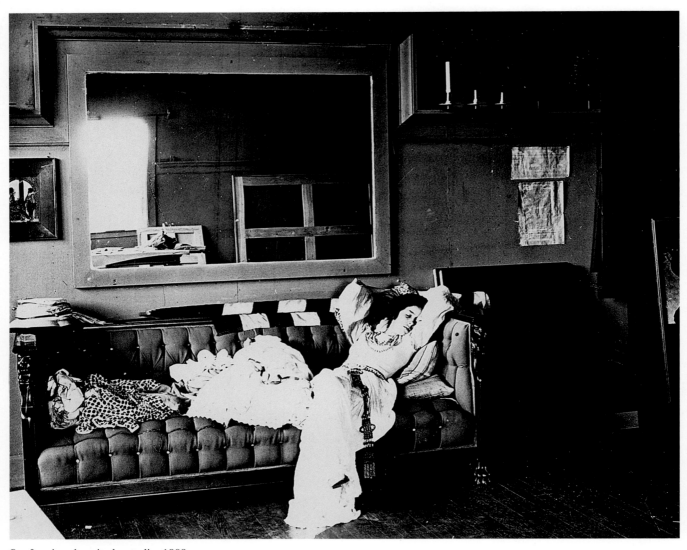

Sue Lewin asleep in the studio, 1909

Notes

CHAPTER ONE

1. Coy Ludwig, Maxfield Parrish (New York: Watson-Guptill, 1973), 19.

2. Quimby to Steve Crimmias, 6 June 1979. The Oral Histories of Maxfield Parrish. The Brandywine Museum, Chaddsford, Pennsylvania.

CHAPTER TWO

3. Bishop, 1979. The Oral Histories of Maxfield Parrish. The Brandywine Museum, Chaddsford, Pennsylvania.

4. Parrish, 13 May 1938. Parrish Family Papers. Dartmouth College Special Collections, Hanover, New Hampshire.

5. A copy of Parrish's letter to Mrs. Ruggles is in the collection of The Brandywine Museum, Chaddsford, Pennsylvania.

CHAPTER FOUR

6. "The Most Beautiful Dining Room in America," Ladies Home Journal (August 1912).

7. Parrish Family Papers. Dartmouth College Special Collections, Hanover, New Hampshire.

8. Ibid.

9. Ladies Home Journal (May 1912).

10. Parrish, 27 July 1911. Parrish Family Papers. Dartmouth College Special Collections, Hanover, New Hampshire.

CHAPTER FIVE

11. Parrish Family Papers. Dartmouth College Special Collections, Hanover, New Hampshire.

12. As quoted by Marguerite Quimby, 6 June 1979. The Oral Histories of Maxfield Parrish. The Brandywine Museum, Chaddsford, Pennsylvania.

13. Parrish, Jr., December 1978. Collection of Alma Gilbert, Burlingame, California.

CHAPTER SIX

14. "The Frog Prince," Hearst Magazine (July 1912).

CHAPTER SEVEN

15. Wisehart, "Maxfield Parrish Tells Why the First Forty Years Are the Hardest," American Magazine (May 1930).

16. Parrish, 28 July 1943. Parrish Family Papers. Dartmouth College Special Collections, Hanover, New Hampshire.

17. Parrish, February 1938. Parrish Family Papers. Dartmouth College Special Collections, Hanover, New Hampshire.

CHAPTER EIGHT

18. "Grand Pop," Time, 12 June 1964, 76.

19. "When Maxfield Parrish Turned to Poetry," Herald Traveler, 19 June 1963.

20. Ibid.

CHAPTER NINE

21. Cortissoz, "Recent Works by Maxfield Parrish," New York Herald Tribune, 16 February 1936.

About the Author

ALMA GILBERT purchased The Oaks in 1978 for the purpose of establishing the Maxfield Parrish Museum. She converted Parrish's studio into the museum and compiled oral histories, presented exhibitions of his photographs and paintings and researched his public and private histories for eight years, until the museum closed. Gilbert has been dealing in Parrish originals since 1974. She has been the recognized world authority on Maxfield Parrish's works since his son Maxfield Parrish, Jr.'s death in 1983, and all of his major paintings have passed through her hands at various times.

Alma Gilbert currently owns The Alma Gilbert Gallery in Burlingame, California, where she presents frequent exhibits of Maxfield Parrish's paintings. She resides in the San Francisco Bay Area, where she continues to research Parrish's life and work as she works on a Parrish biography entitled *In the Shadow of the Giant*.